James & Other Apes

James & Other Apes
by James Mollison

Introduction
by Jane Goodall

Introduction by Jane Goodall

James & Other Apes is a magnificent book that will introduce people to a new world, stimulate thinking, and help people to understand better our place in nature – in the scheme of things. For many it will be a humbling experience. We are different from other animals (as they are different from each other) but not as different as we thought.

In 1859 Darwin shocked much of the world with his theory of evolution. It ran contrary to the teachings of the Bible that stated clearly: the world and everything in it was especially created by God. And, worse heresy, Darwin even maintained that Man himself had evolved from apes. Today, although the theory of Special Creation is still preached in some churches – and believed by about a quarter of American graduates – most people accept the idea that we have evolved gradually, like everything else. Not that we descended directly from any of the modern great apes – chimpanzees, bonobos, gorillas and orangutans – but that we shared a common ancestor: a chimp-like human-like creature who lived some six to seven million years ago. Indeed, recent research has revealed startling similarities in the structure of DNA in apes and humans. We differ from chimpanzees by only about one per cent. Chimpanzees and bonobos are closer to humans than they are to gorillas. All three African great apes show more similarities to us than to orangutans.

None of these genetic molecular studies had been carried out when, in 1960, I commenced my study of chimpanzees in the Gombe National Park in Tanzania. It was still widely held, by both science and religion, that a sharp line divided humans from the rest of the animal kingdom; that there was a difference in kind, rather than degree. But, perhaps fortunately, I had not been to university at the time and I started my research with an open mind. The first breakthrough came when I observed a chimpanzee 'fishing' for termites. He picked a grass stem, poked it into the tunnel leading into an underground nest, slowly withdrew it, and picked off the insects with his lips. He was using a tool! Then I saw him pick a twig and strip off the leaves, thus *making* a simple tool. Many scientists were initially reluctant to accept these observations; at the time it was believed that humans and only humans were capable of such behaviour. Indeed, what supposedly defined us as Man rather than animal was our capacity for making tools. When my mentor, Louis Leakey, received my news by telegram he replied 'Now we must redefine "Man", redefine "tool" – or accept chimpanzees as human!'

We now know that the great apes are capable of many intellectual behaviours once thought unique to us – hardly surprising, in view of similarities in the anatomy of our brains. In each of the places in Africa where chimpanzees have been studied, they have developed different kinds of tool-using behaviours. These are passed from one generation to the next by observation, imitation and practice. In other words, they represent *cultural* traditions. The same is true for the other great apes. And they all show emotions that are clearly similar to if not the same as those that we label, in ourselves,

pleasure, sadness, anger, despair and so on. They are capable of compassion and altruism on the one hand, rage and brutality on the other – a brutality that in chimpanzees can lead to a form of primitive warfare. Many of their non-verbal communication patterns are uncannily similar to some of ours: kissing, embracing, patting each other, tickling, laughing, swaggering, punching, begging with an outstretched hand. And these gestures and postures occur in the same kind of situation that elicit them in humans. They mean the same kind of thing. Close, affectionate, supportive bonds may persist between certain individuals, especially family members, throughout a life of up to 60 or more years.

After a year at Gombe, I was accepted to work for a PhD at Cambridge University. There I found that I had not followed acceptable scientific methods. I had named rather than numbered the Gombe individuals as I got to know them. Because I maintained that chimpanzees had minds capable of rational thought, and emotions of a similar nature to our own, I was guilty of anthropomorphism – the attributing of human behaviours to non-human beings. Particularly shocking was the fact that I was talking about personality differences: calm, dignified David Greybeard (the first to lose his fear of the strange white ape that was so terrifying at first); bold, short tempered Goliath (the alpha male back then); crusty, irascible JB; assertive Flo, beloved of the males and affectionate, supportive mother; high-ranking Passion, a brusque, even harsh mother; timid Olly with her goitre. And all the rest. Such vivid personalities,

each one as different from the others as kids in a school classroom.

I have not studied the other great apes, but I have met many during my travels. I saw one wild orangutan in Borneo, and I met many of the orphans at Biruté Galdikas's Indonesian rehabilitation centre. I will never forget juvenile Alex and the slightly older Annabelle, two orangutans I was introduced to when I worked in the film unit at London Zoo in the late 1950s. These Asian apes are the most charming of them all when young, with their dark eyes, huge in pale faces, and absurd tufts of ginger hair standing up on top of their heads. Their movements are slow and deliberate; they seem to think through each move before they make it. Alex and Annabelle, along with Congo, a young chimpanzee, were taking part in a TV show that was to demonstrate ape intelligence. I was given the privilege of driving the orangutans to the studio in my tiny, open-topped car. They sat on the back seat with their keeper, to the amazement and delight of passers by!

Their tasks were relatively simple, and Congo, with the normal extroverted personality of his species, and his love of showing off, performed them all with aplomb. Alex, in a more deliberate and less exuberant way, also did quite well. Annabelle sat, looked at the test situation, then simply folded her long arms on the table, laid her head on them, and closed her eyes. It was as though she said to herself 'What's the point?' As she was not hungry, she saw no reason to exert herself!

I was introduced to a gorilla family in the Goualougo National Park in Congo-

Brazzaville. The young mother, Angela, with one-and-a-half year-old Axel on her back, was the first to emerge from the forest into the green, grassy, swampy meadow, known as a 'bei'. She settled down to feed on great handfuls of water-weed that she scooped from a channel running through the swamp. But after only a few minutes Axel jumped from her back and set off to explore. Deeming this unsafe, she set off to gather him up. This was repeated again and again. Until Sassoon, the magnificent silverback, emerged from the forest. Then the harassed mother relaxed and allowed Axel to play around his father, showing off and taking all manner of liberties – which Sassoon completely ignored! Next Barbara arrived with Jacko close on her heels. He was six, the researchers told me, but still suckling. And finally Antonia appeared with a tiny baby who could not have been more than three days old. We watched them for about an hour, from a specially constructed observation platform, until Sassoon led his little family back into the forest.

How different my first meeting with a gorilla. Guy was a prisoner at London Zoo along with Congo and the two young orangutans. When I met him he had been alone for years in a small cement-floored cage, surrounded by iron bars, and with nothing – absolutely nothing – to do. He had developed many bizarre behaviours as a result of crippling boredom. Finally, after I had left, a three year-old female was purchased (as a prospective mate) and caged next to him so that they could become acquainted gradually. They could see, hear and smell each other,

and touch fingers through the bars that separated them. I just happened to be at the zoo on the very day she was allowed into Guy's cage. The huge male lay on his back. The little female approached slowly – even lying down he must have seemed huge to her. Very slowly, trembling with excitement, Guy reached out and drew her close, lifted her to his chest, cradled her close. Gently he groomed her, every movement tentative, as though he was terrified of doing something that would bring this magical moment to an end. There was not a dry eye among those watching; as for me, tears were pouring down my face.

It was the same with old Gregoire in Brazzaville Zoo. When I met him in 1991 he was a living skeleton, every bone in his body visible, almost hairless from malnutrition. Over his dark, barren cage was a notice, 'Gregoire. Schimpansc. 1944'. How had he stayed alive all those bleak years? I was glad I met him, and just in time. We (JGI, the Jane Goodall Institute) employed a keeper and persuaded a group of ex-pats to save food and take it to the zoo. Finally we raised money to build him a little patio and, for the first time in years, he felt the sun on his back. And then we introduced a female orphan, one-and-a-half year-old Cherie. Like Guy, Gregoire reached for her so slowly, so gently. They became inseparable, the old man and the little girl, grooming, playing and sleeping at night curled up together on their straw bed. Eventually we moved them both to the JGI Tchimpounga sanctuary near Pointe Noire on Congo's west coast.

I have met a number of bonobos over the years. The one I knew best was another

orphan, whose mother was almost certainly shot for meat. He was handed over to the gorilla orphanage at Brazzaville Zoo. Once he had recovered from his injuries he was introduced to a group of young gorillas where, despite his much smaller size, he soon assumed the dominant position. This was entirely due to his assertive, mischievous disposition, his absolute lack of fear, and his quick intellect. The bonobo, long known as 'the Pigmy Chimpanzee', is less aggressive, more sexual – the females are sexually receptive almost all the time – and, some believe, more intelligent than the chimpanzee. Certainly they do well in language acquisition programmes in captivity.

One of Gregoire's companions in our Tchimpounga sanctuary in the Congo is La Vieille. When I first met her she certainly looked old – she sat emaciated and listless, day after day, in a small rusted cage in Pointe Noire. The lock on the door of her prison was broken. There was nothing, except her own neurosis, to prevent her escape. But she would not leave the cage, not even for the most tempting food. Even after we moved her to our sanctuary it was at least six years before La Vieille dared step out of her concrete sleeping room onto the sand of the main enclosure. Again and again she would build up her courage, bristling her hair and swaying back and forth. Then she would lunge towards the door... Surely she would make it? But no, she pulled back at the last moment, again and again. Finally she overcame her irrational fear, with the help of the Congolese staff. Today she wanders around with Gregoire on a small grassy lawn, enjoying the sunshine and watching the younger chimps out in their big enclosure.

In most of the places where they range, the great apes face extinction within the next ten to fifteen years if we do not act to save them. There were probably close to two million chimpanzees across Africa 100 years ago. Today there are no more than 150,000. They are declining in numbers as a result of ever-growing human populations, constantly encroaching the remaining forests, fragmenting remaining habitats, setting snares and hunting. The situation is even worse for mountain gorillas and orangutans. As wild ape numbers decrease, so the population of orphans in sanctuaries is increasing. Chimpanzees, gorillas and bonobos are being hunted, along with elephants, antelopes and myriad other species, for food – and not to feed starving people, but to satisfy a taste for 'bushmeat' among the urban elite. Subsistence hunting, a way of life for the Africans living in the forests of west and central Africa, became commercial when foreign logging companies began opening up previously inaccessible areas with roads, providing hunters with passage. There is not much meat on an infant ape, so often it will be sold alive, illegally, in the market beside the cut-up body of its mother. These are the orphans, confiscated from illegal traders, that make up the population of at least nine sanctuaries.

It is the same in Asia where several sanctuaries receive a never-ending series of pathetic infants whose mothers are killed

after coming into contact with illegal loggers or as a result of the terrible fires that drive them out of the forest. 90% of the apes photographed for this book are orphans from the bushmeat or pet trade. Many of them have seen their mothers killed, and sometimes butchered, in front of their eyes. Each individual ape has his or her own tragic story of pain and trauma. Each one is different.

In a way I have built up my career by describing the individuality of each and every creature I have studied – Rusty the dog, my childhood companion; the spotted hyenas I observed in the Ngorongoro Crater; the chimpanzees of Gombe. Thus I am delighted and honoured to be writing a foreword to James Mollison's stunning collection of ape portraits. Each one captures the unique individuality of his subject. Look into the eyes of each one of them and you will sense their unique personality. The way James has chosen to photograph them is typical for describing humans – full face, passport style – but unusual for apes. We are too used to seeing them performing for our entertainment – 'cute' young apes, dressed in human clothes, or apes who have been taught to 'smile' or pull faces.

The training of apes in entertainment, including the picture postcard industry, too often involves harsh and brutal discipline. And when the apes are too old or too strong for further work, what happens to them? What happens to those raised as 'pets' – treated like part of the family until they become potentially dangerous? Only a fortunate few end up in sanctuaries or really good zoos. Most zoos don't want them because the apes

aren't able to readapt to that environment or to their social group. It used to be the case that chimpanzees would be sold for medical research, before their use in research programmes was gradually phased out. So most end up in small zoos trying to build up their collections – like stamps or art or any other inanimate object that people collect. Often these zoos are not well funded. Sometimes they have little regard for the animals in their care. It keeps me awake thinking of their miserable, wasted lives.

Perhaps the most significant difference between humans and apes is the fact that we have developed a sophisticated spoken language. And this, I believe, contributed to the explosive development of our intellect. We can teach our children about things not present, make plans for the distant future, discuss ideas so that we can benefit from the wisdom of a group. We've developed technology that is a far cry from the chimpanzee-like tools of our remote ancestors. We've sent men to the moon, created marvels of medical technology, and developed global information networks. And we can take photographs that freeze a message in an individual ape's eyes allowing countless viewers to be moved. Surely, together, with these talents at our disposal, we can also save the great apes?

This collection will help. Thank you James Mollison.

Jane Goodall PhD, DBE, Founder the Jane Goodall Institute & UN Messenger of Peace, www.janegoodall.org

Chim

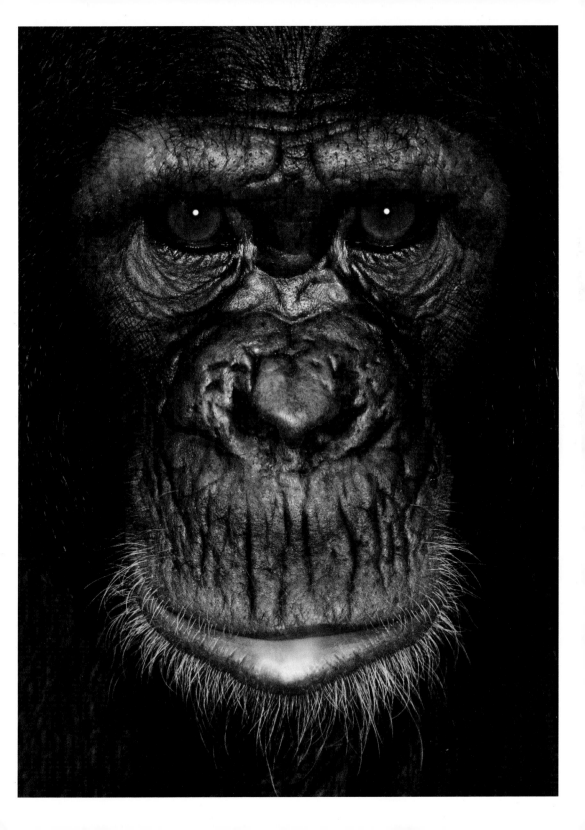

Talian

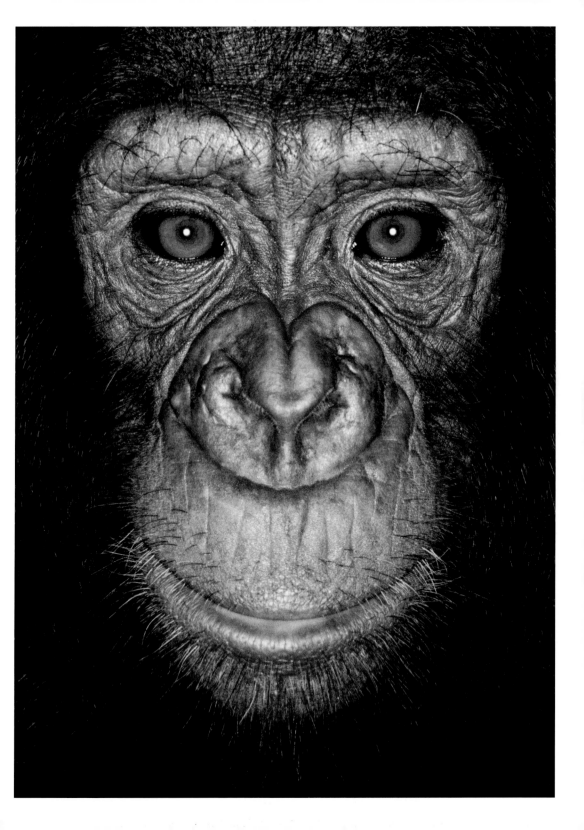

Tam Tam

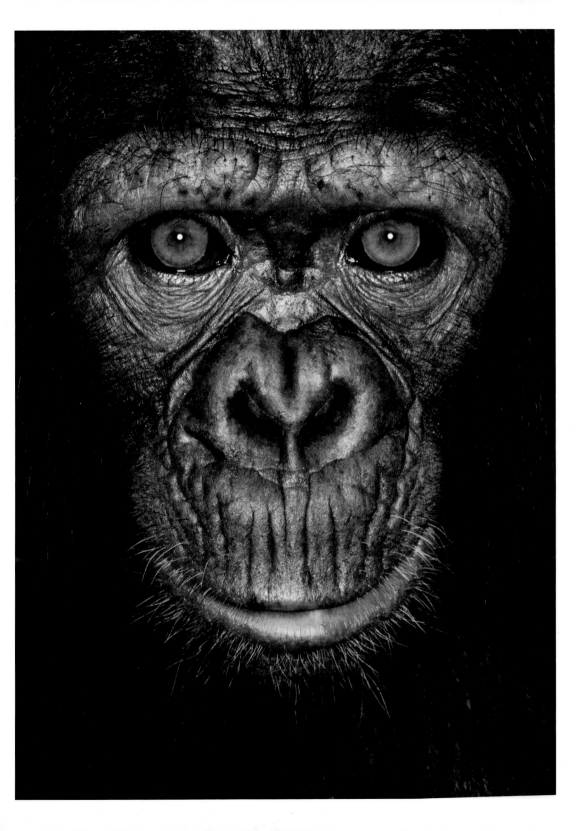

Wazak

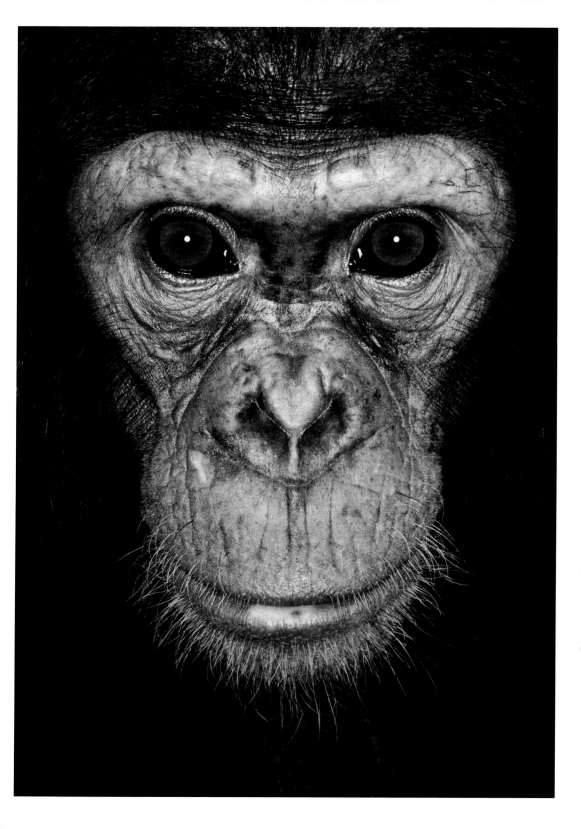

O'Minou

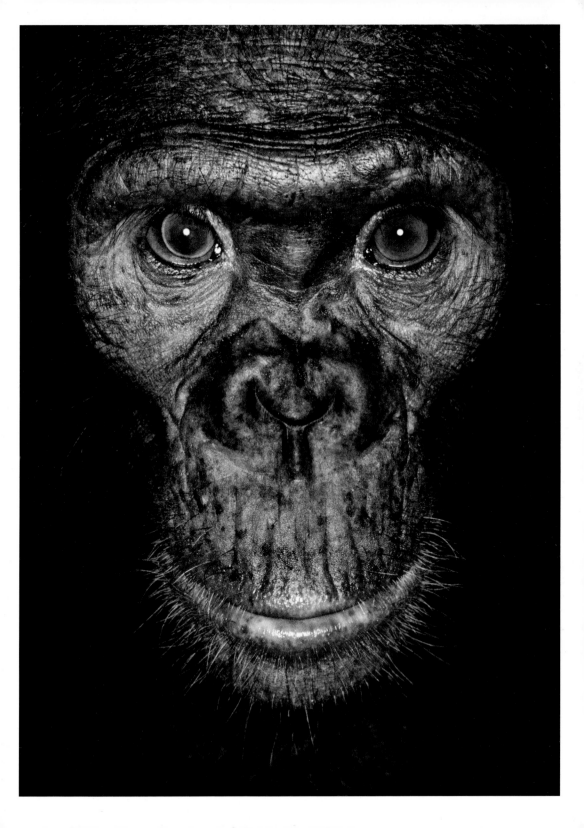

Achille

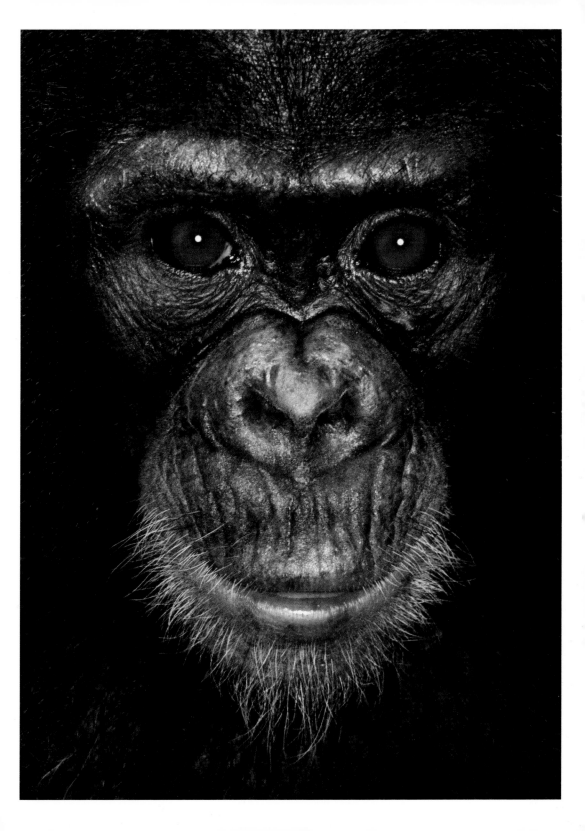

Fani'tuek

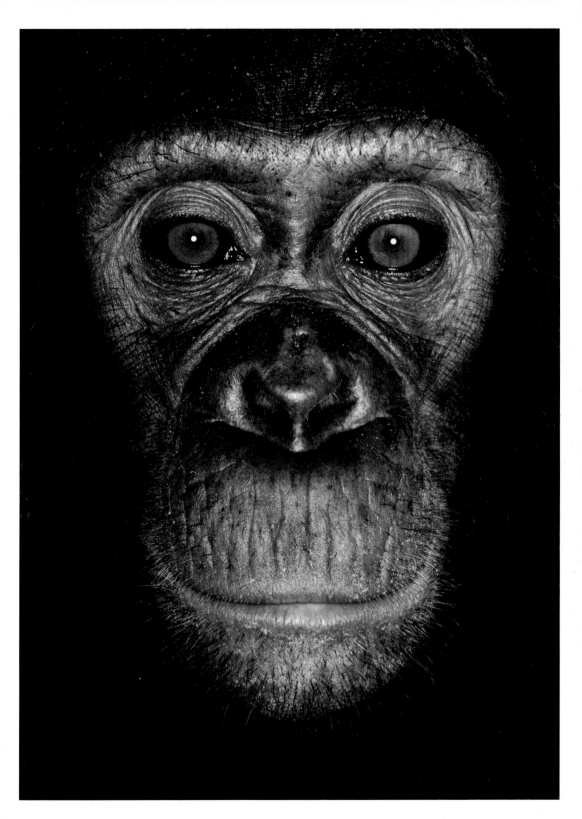

Liana

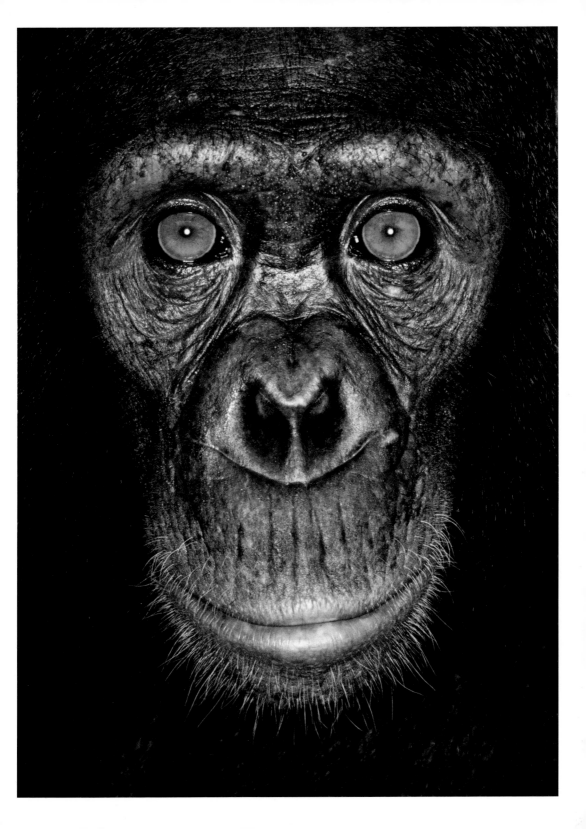

Jackson

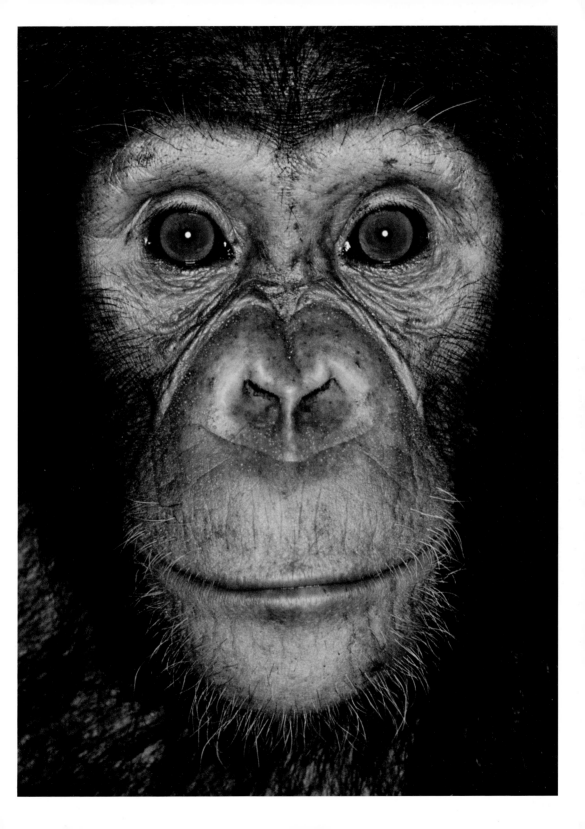

Arron

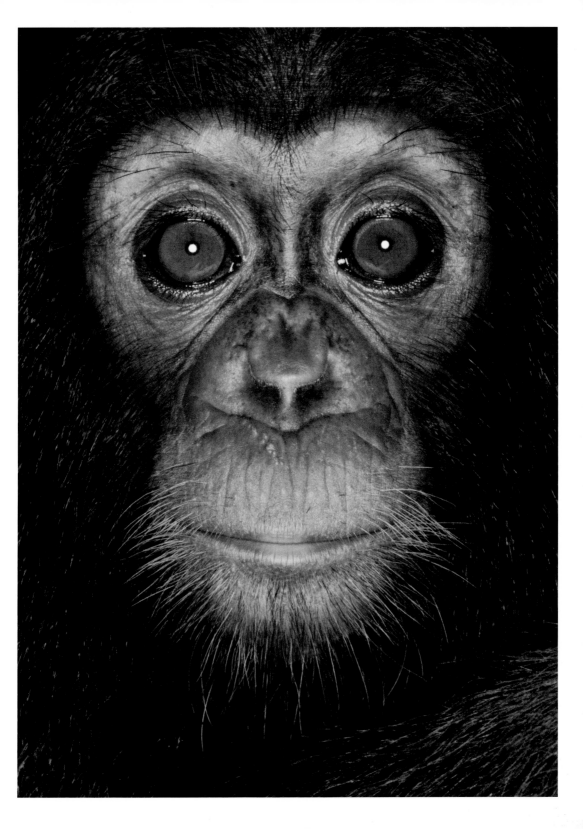

Katie

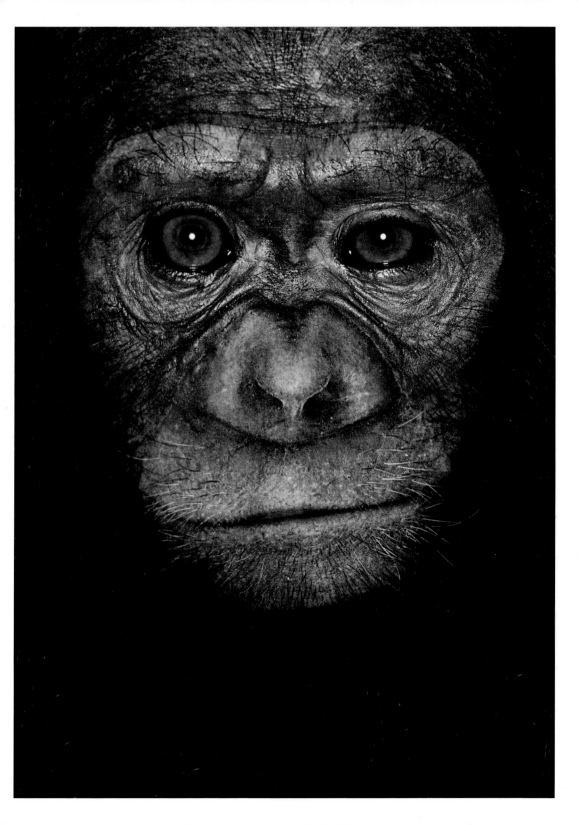

Talila

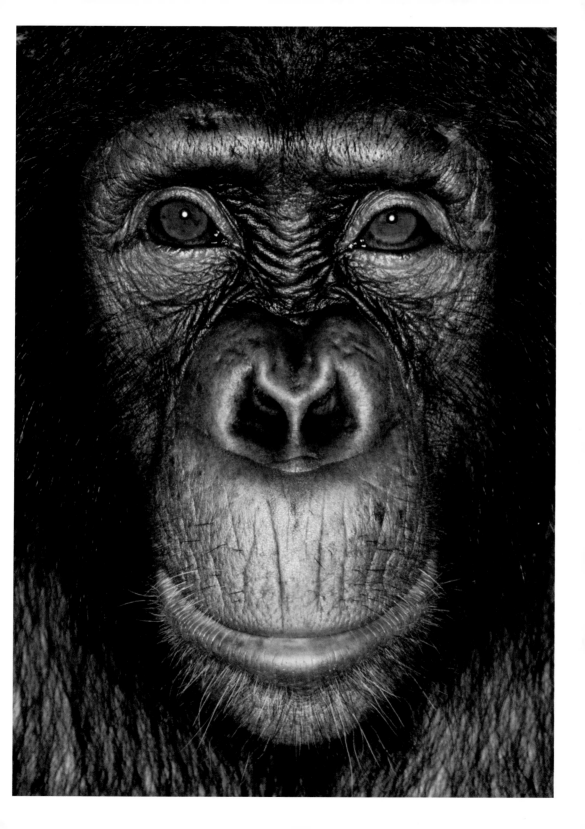

Rambo

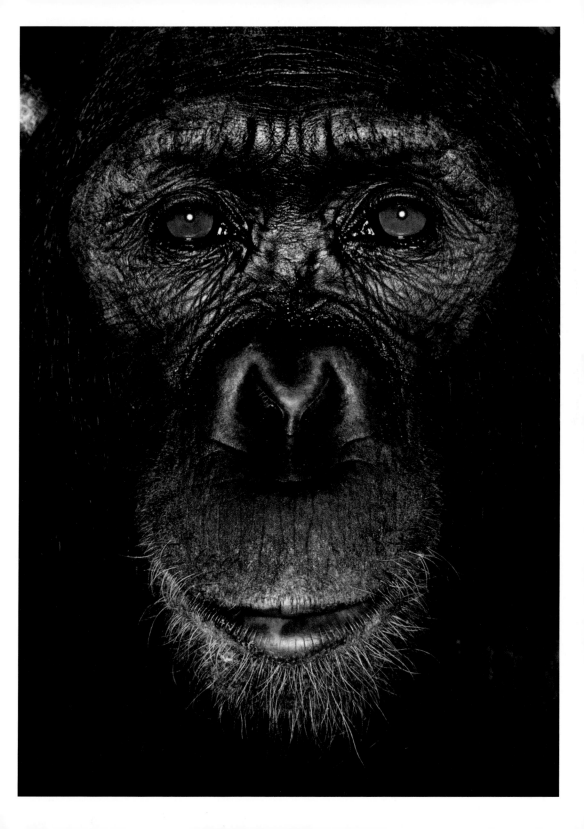

Gregoire

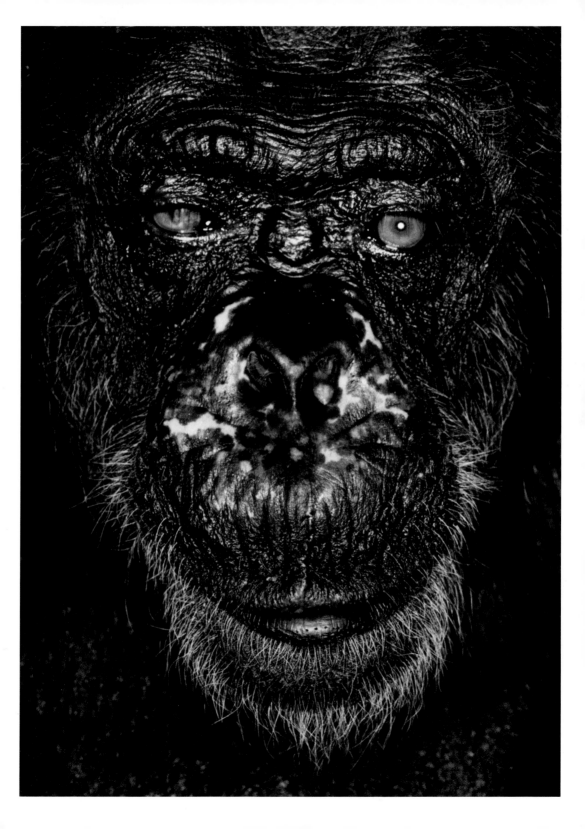

La Vielle

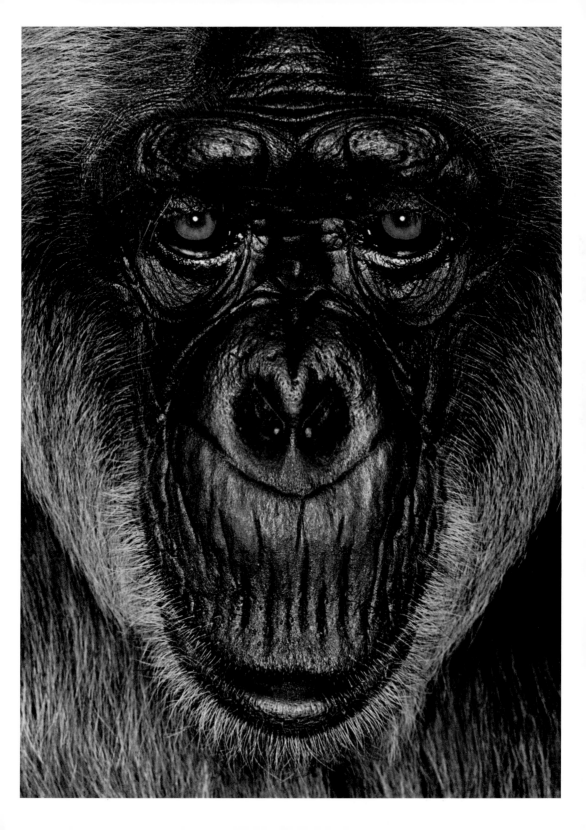

Wendy

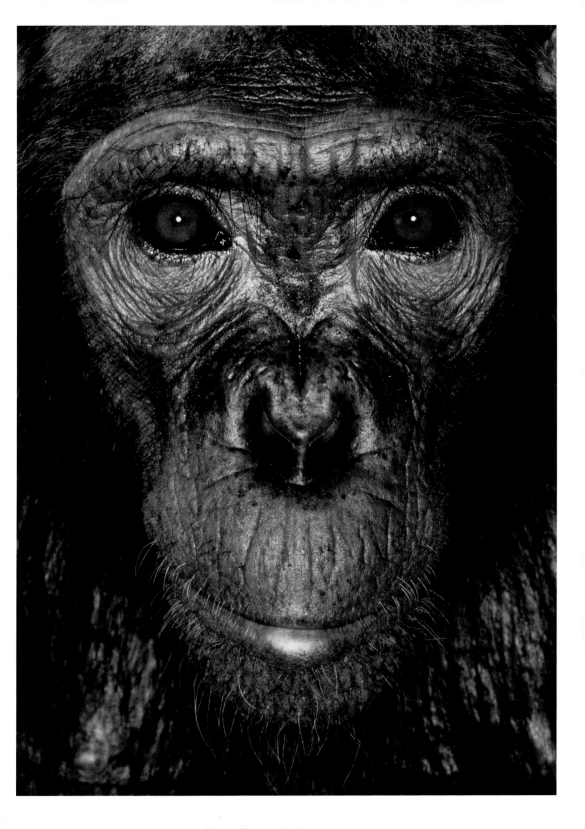

Koffi

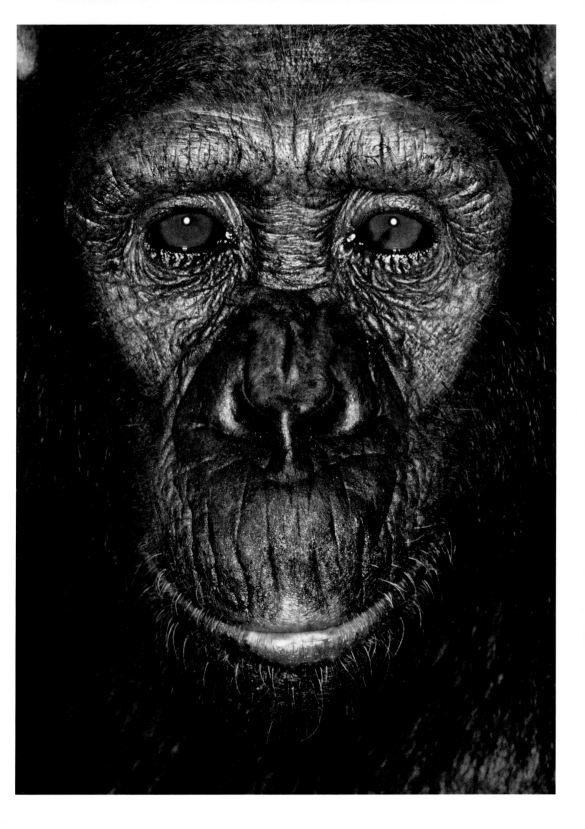

James

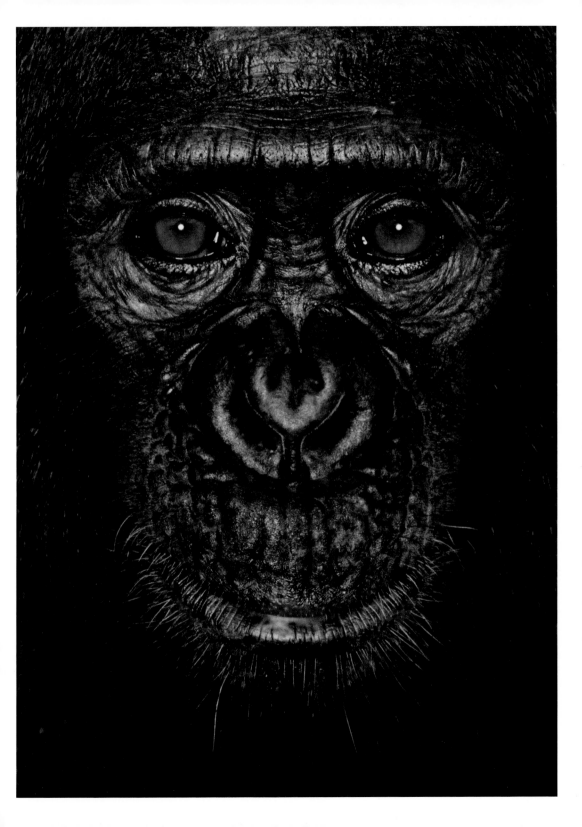

Pumbu

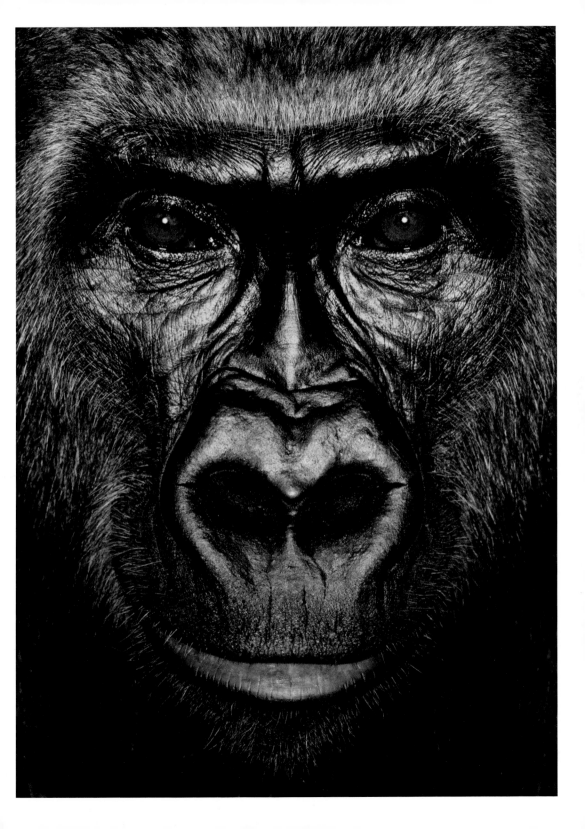

Kibu

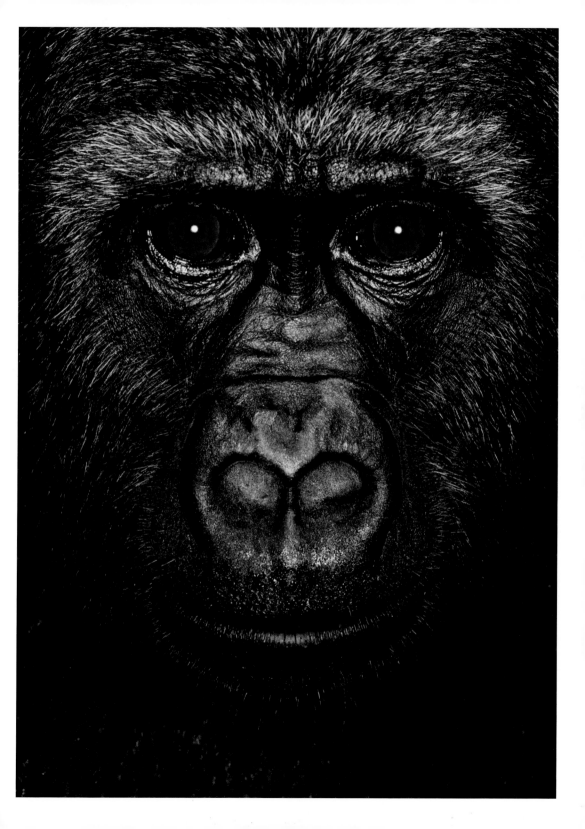

Lulu

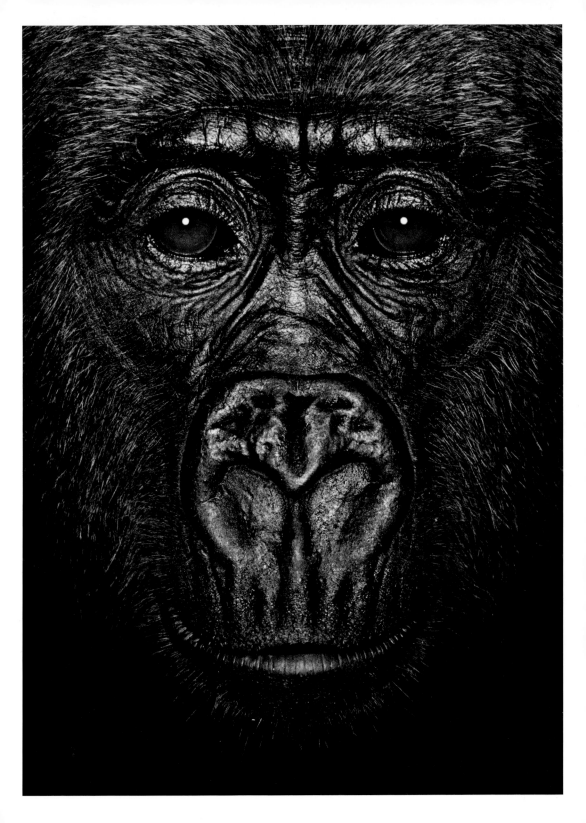

Nyango

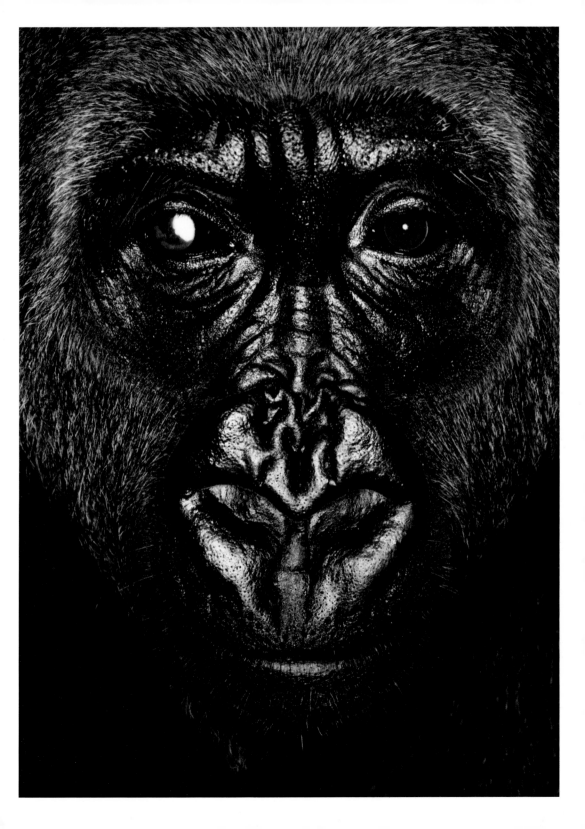

Koto

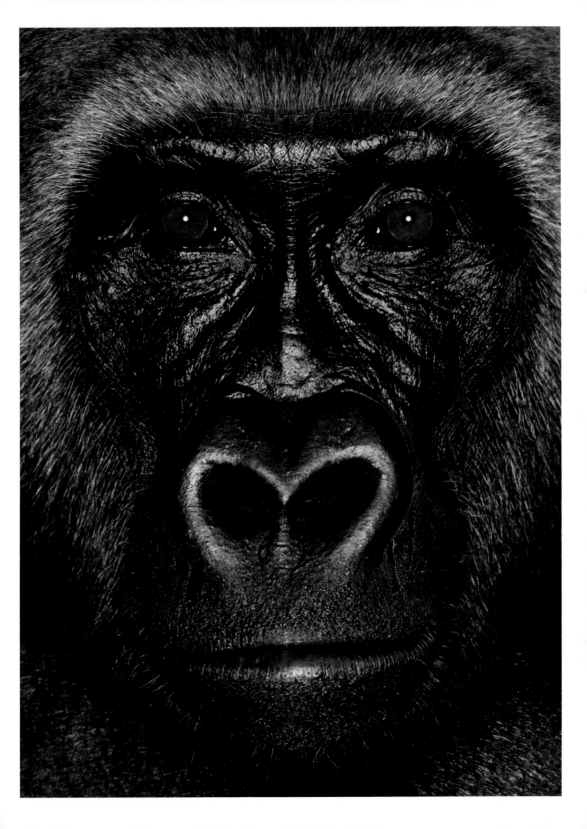

Djeke

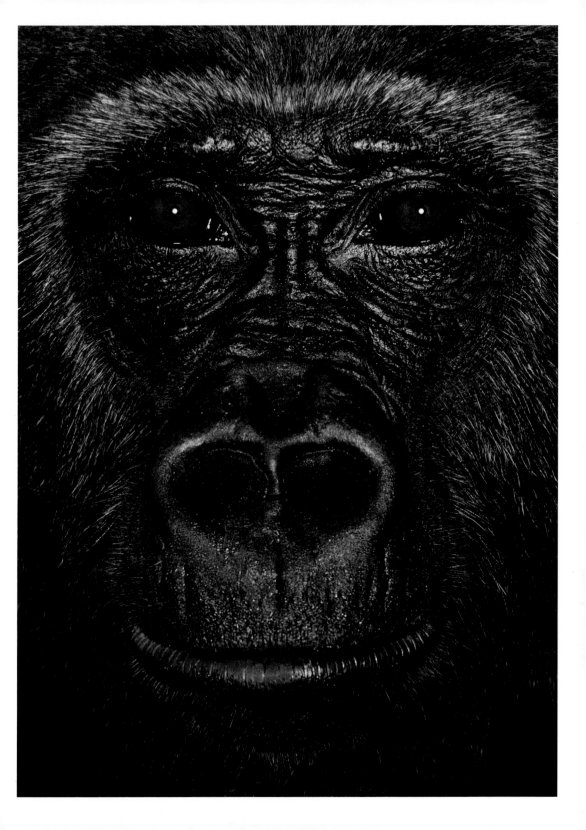

Kola

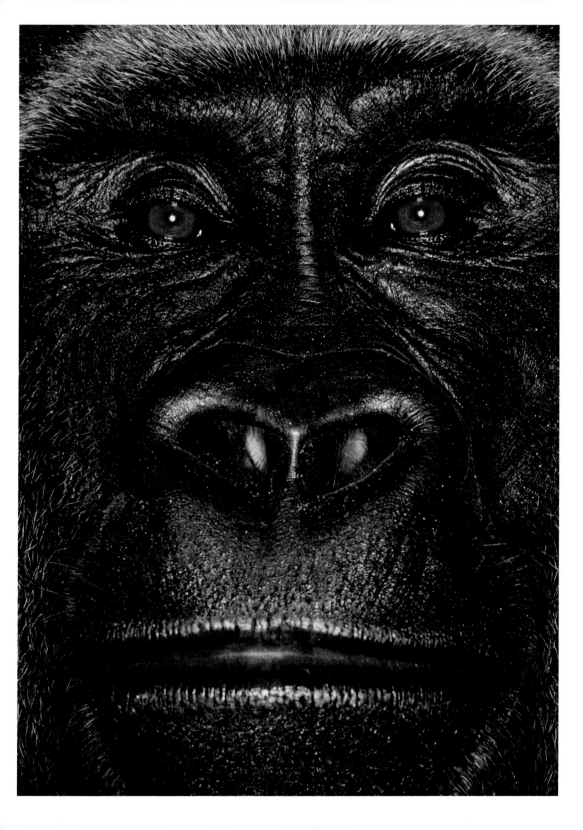

Likendze

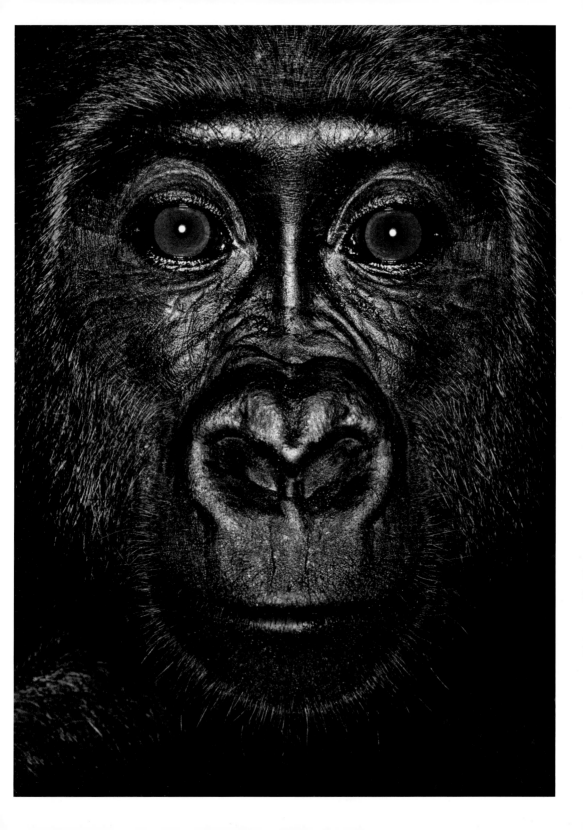

Matoko

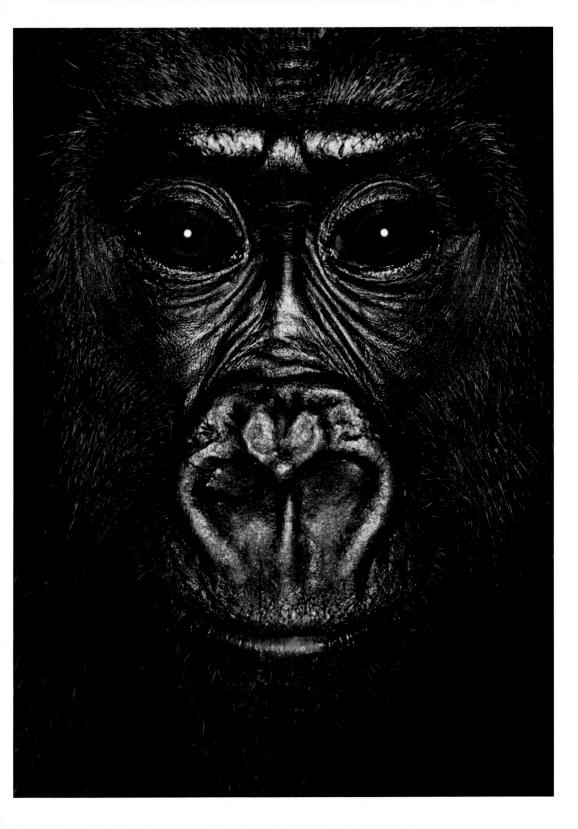

Helene

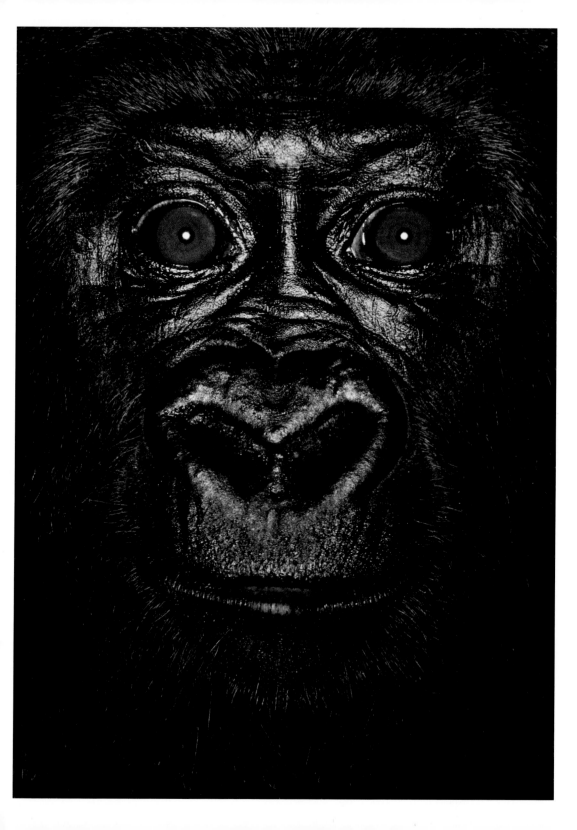

Nkan

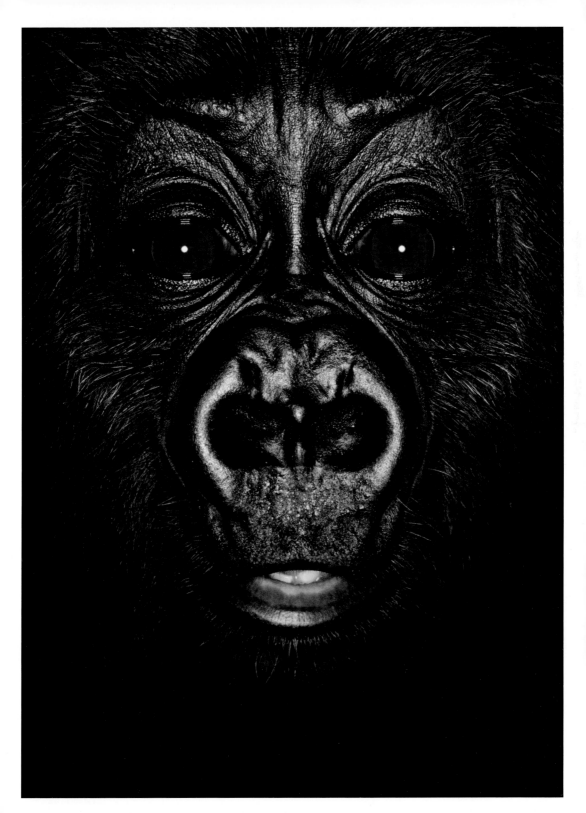

Shanga

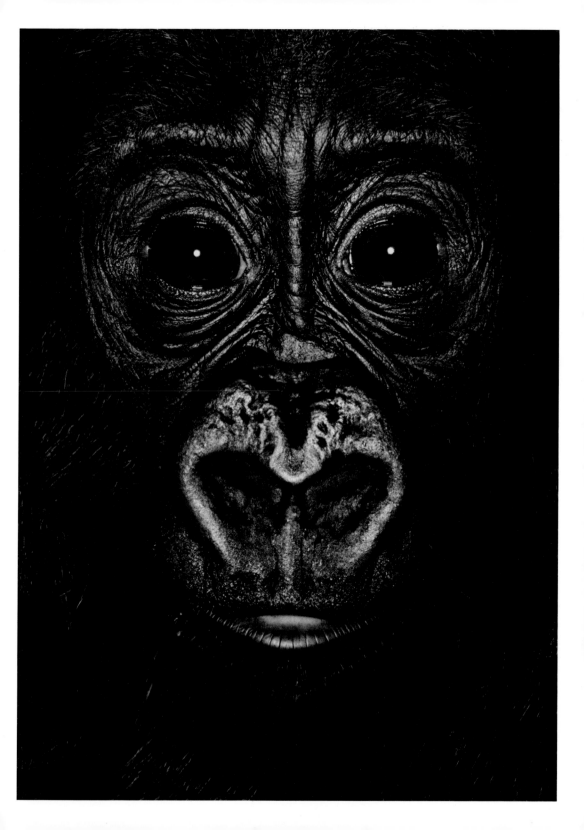

Joji

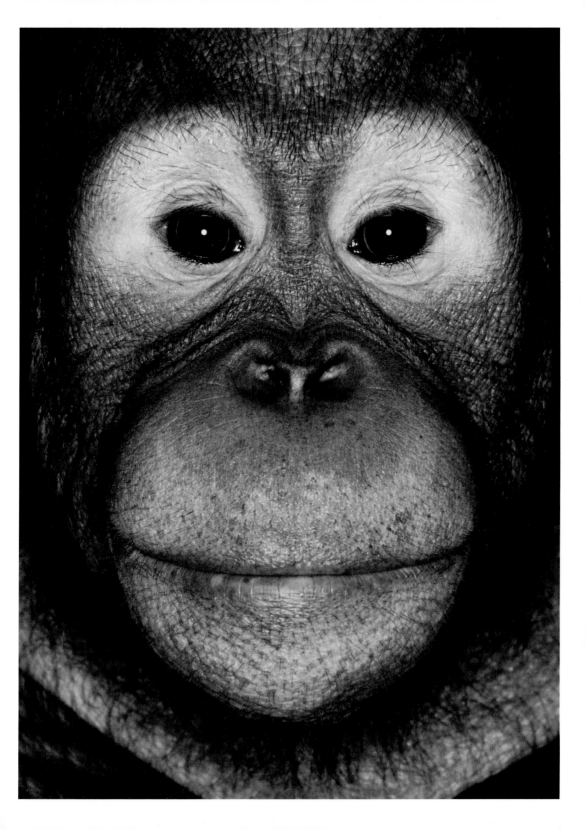

Haidar

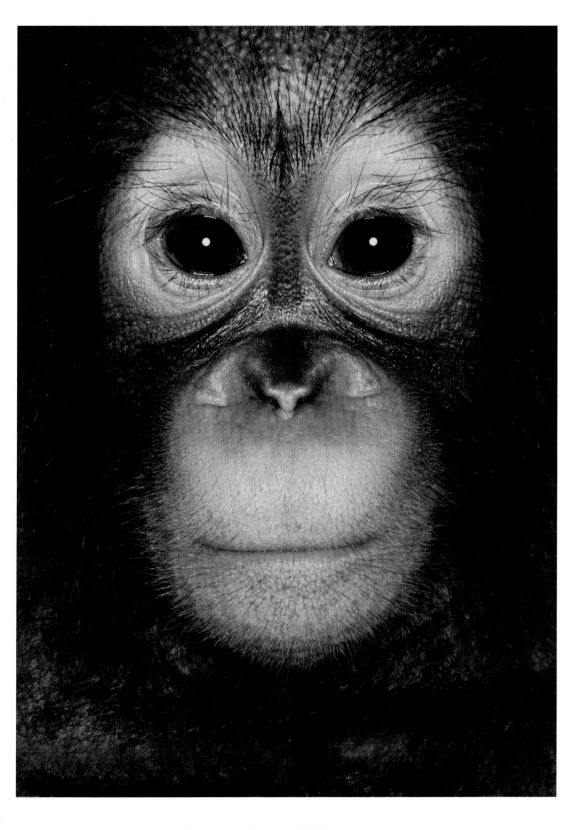

Kudel

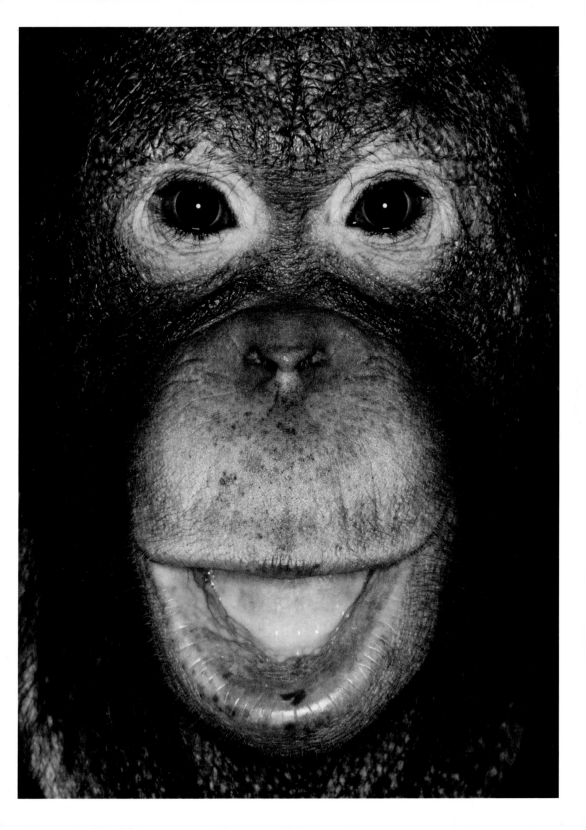

Ya-uuk

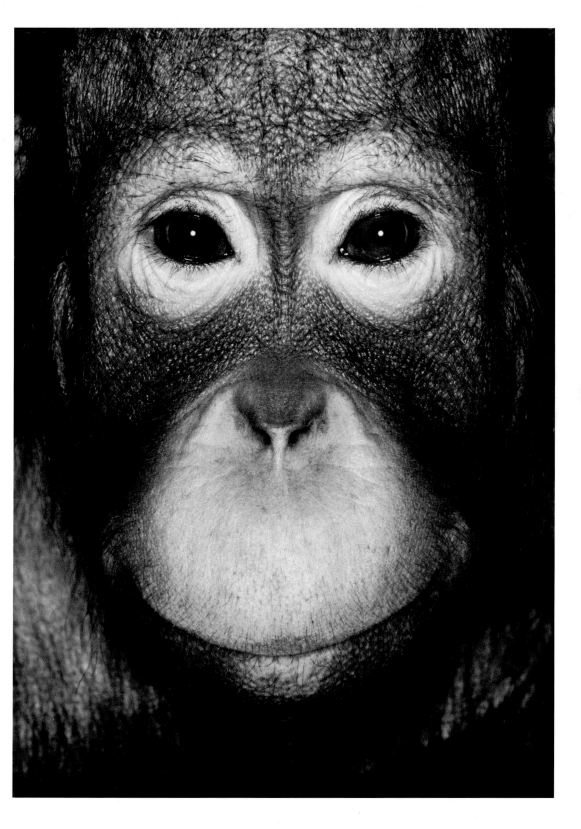

Simon

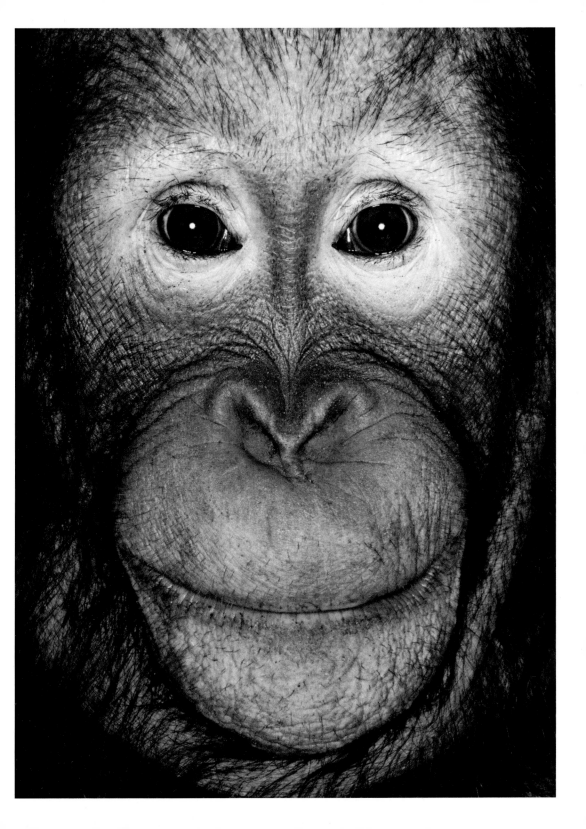

Inge

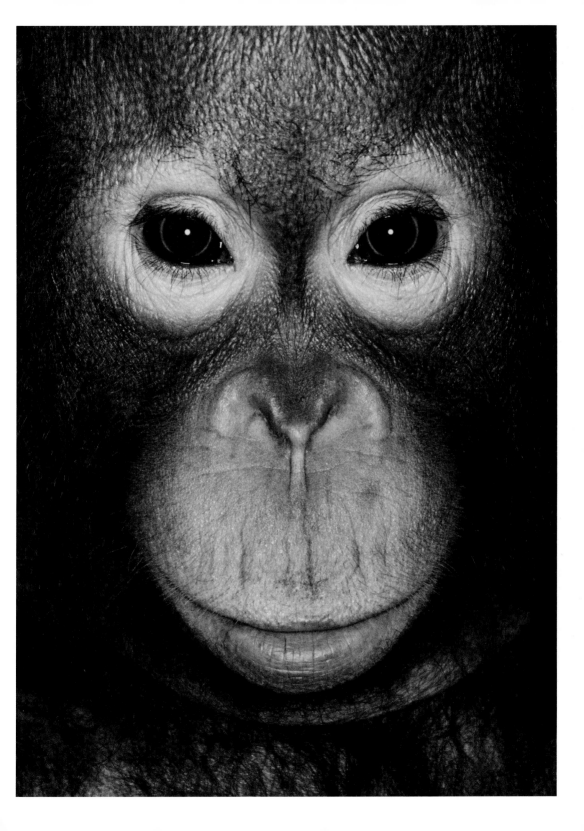

Zidane

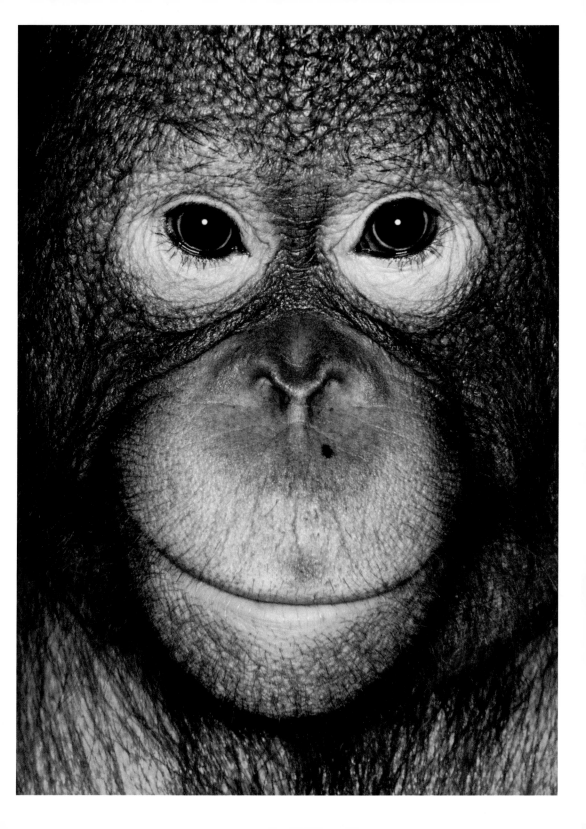

Bonny

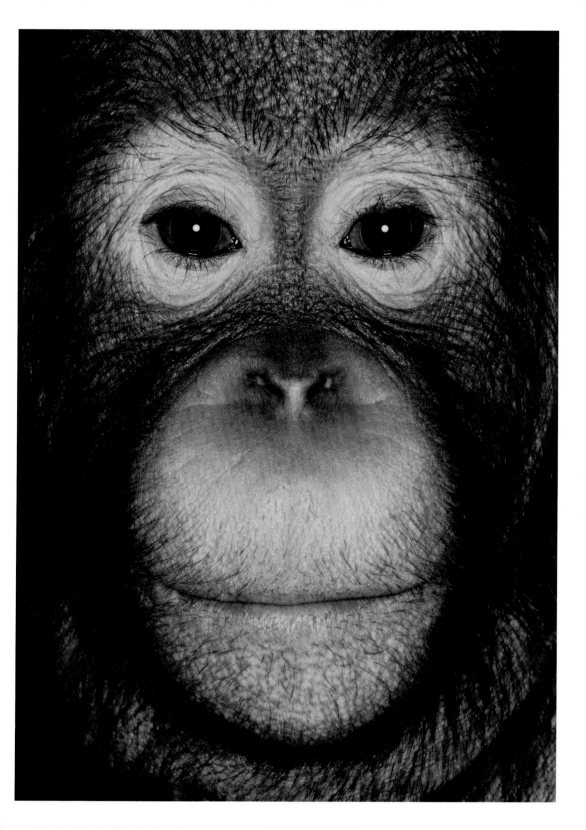

Jovan

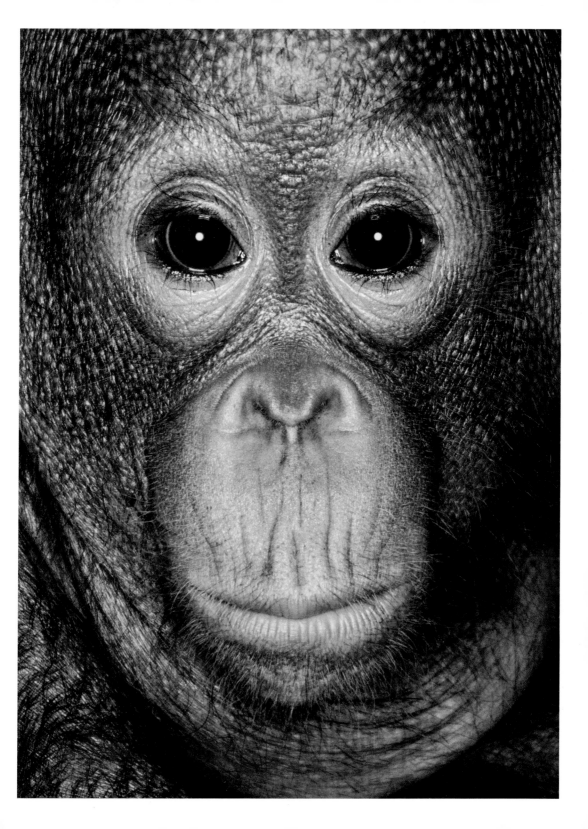

Ciu

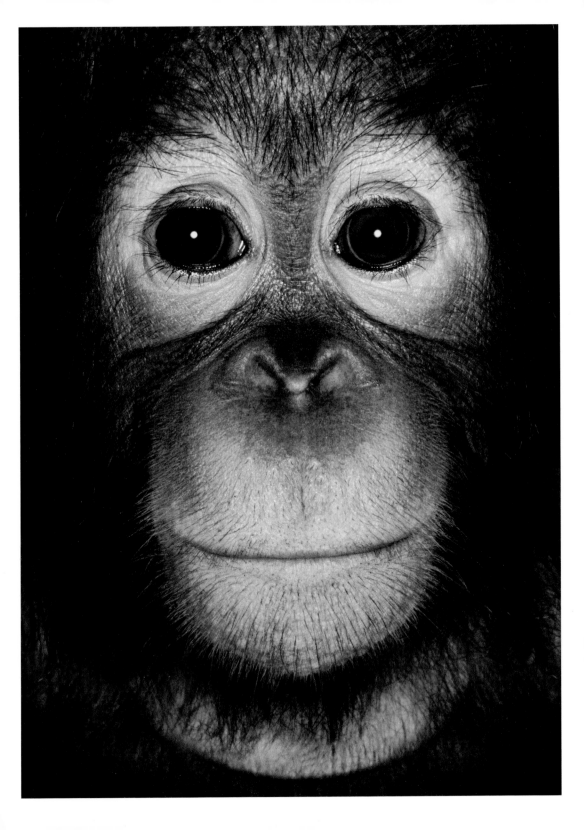

Millie

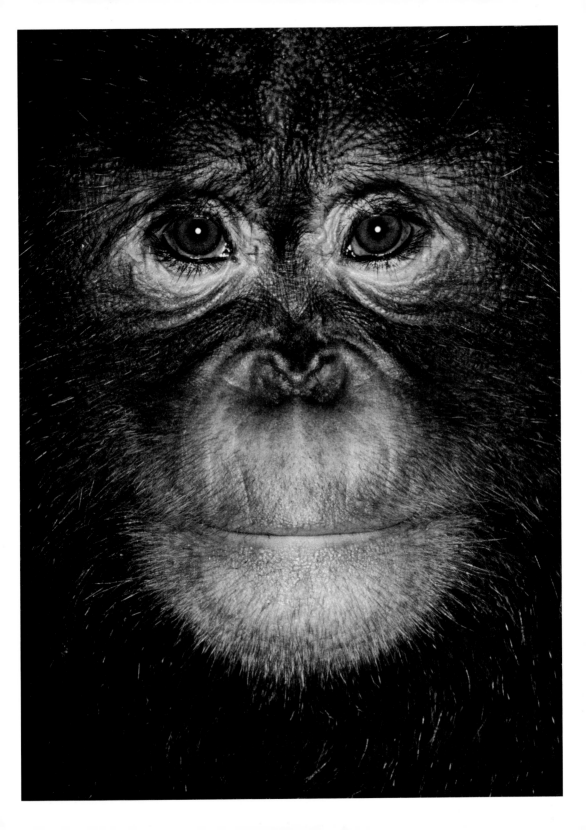

Rio

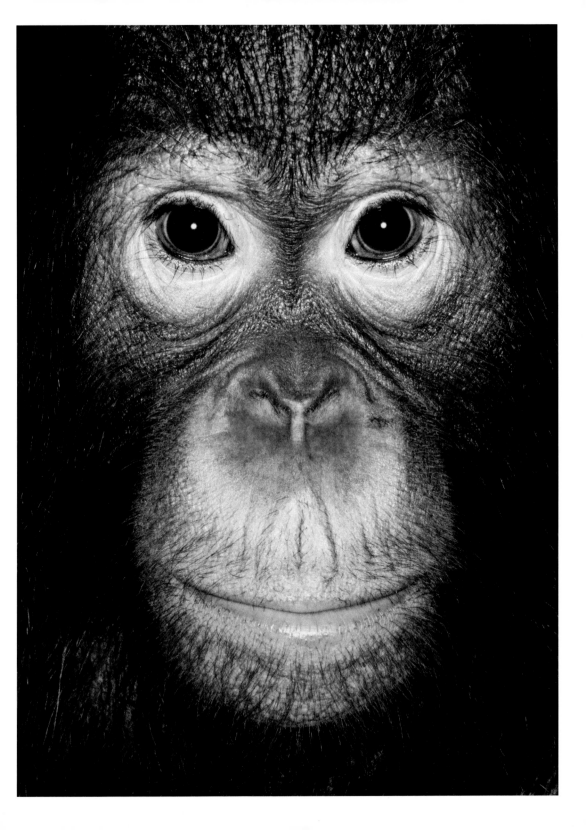

Tatango

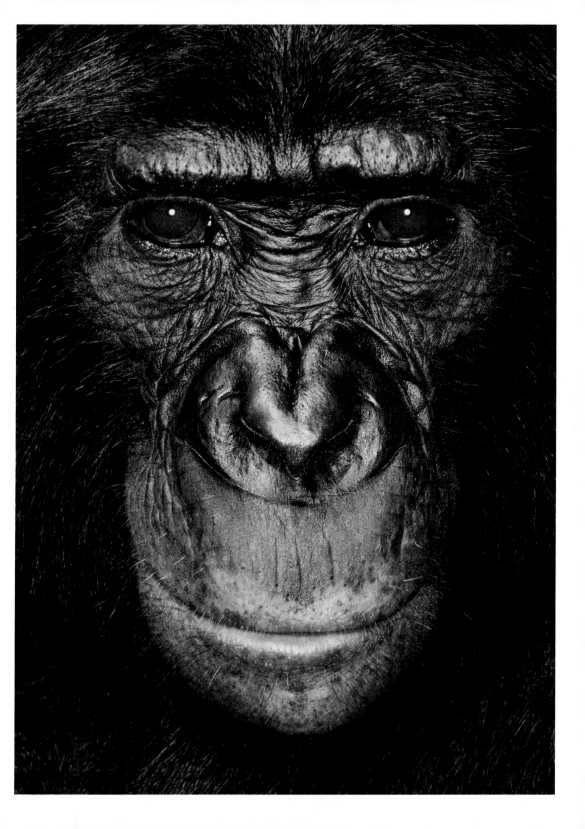

Noiki

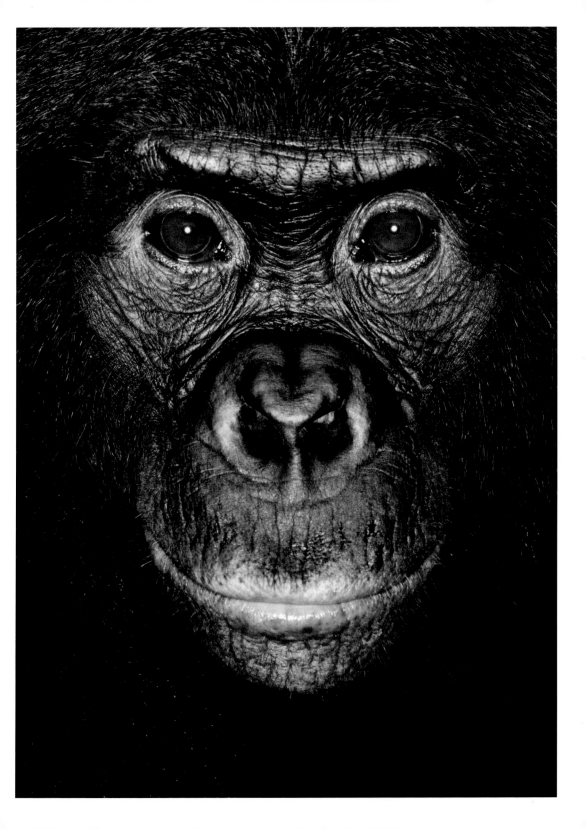

Inogo

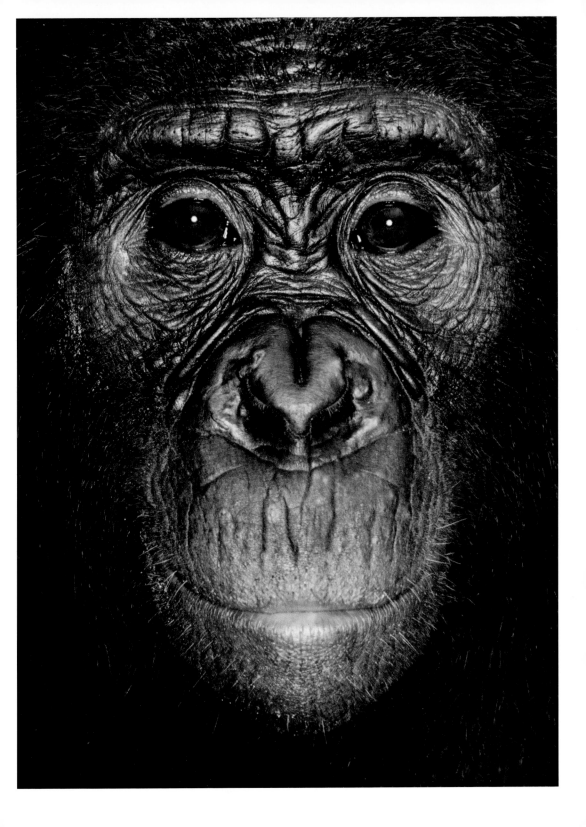

Likasi

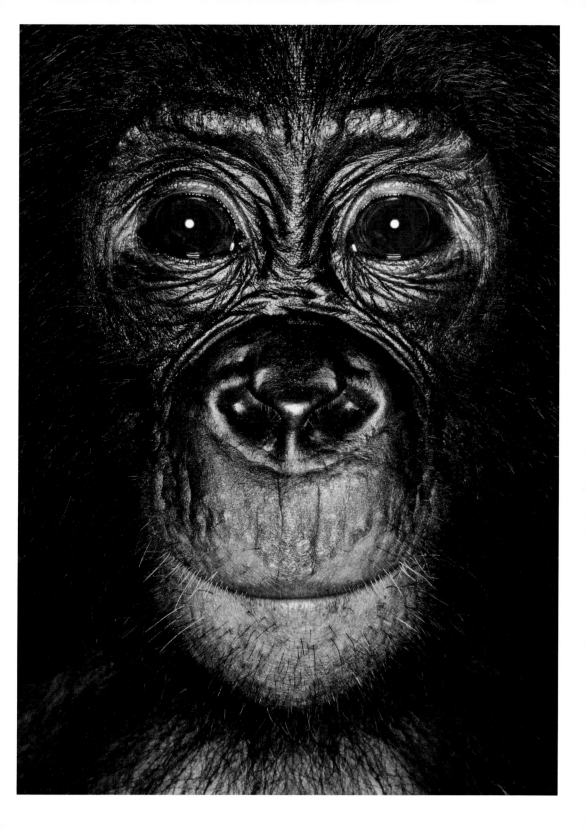

Lisala

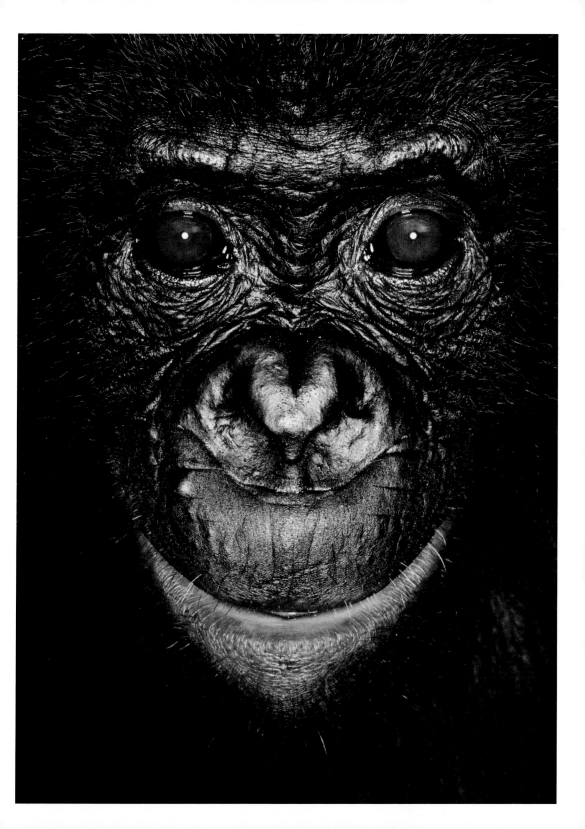

Fizi

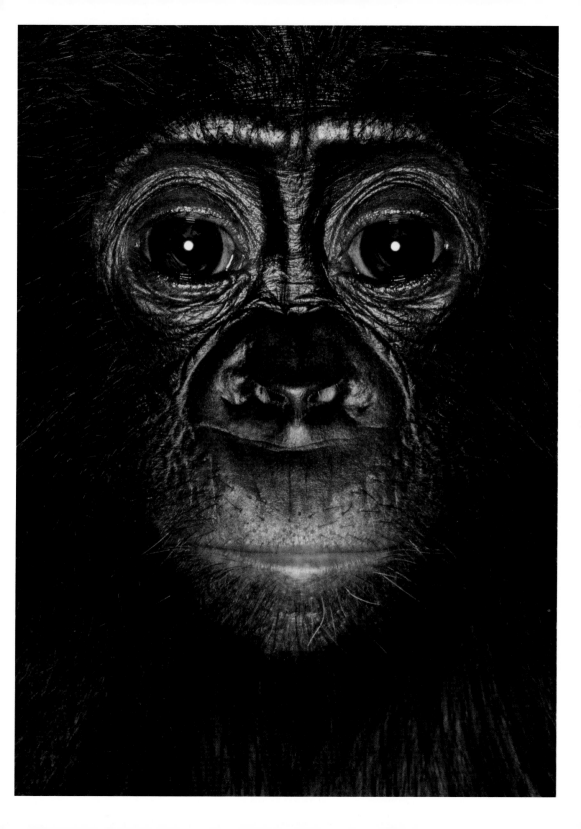

Dilolo

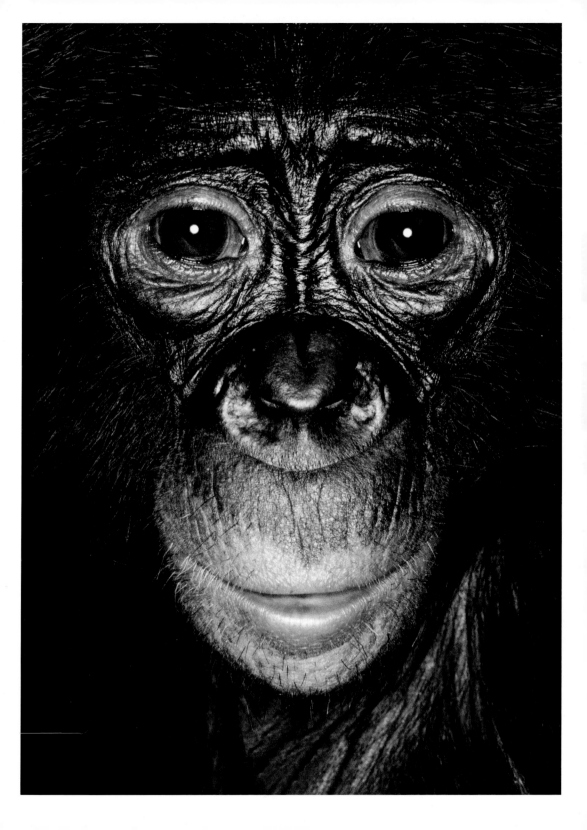

Kikwiti

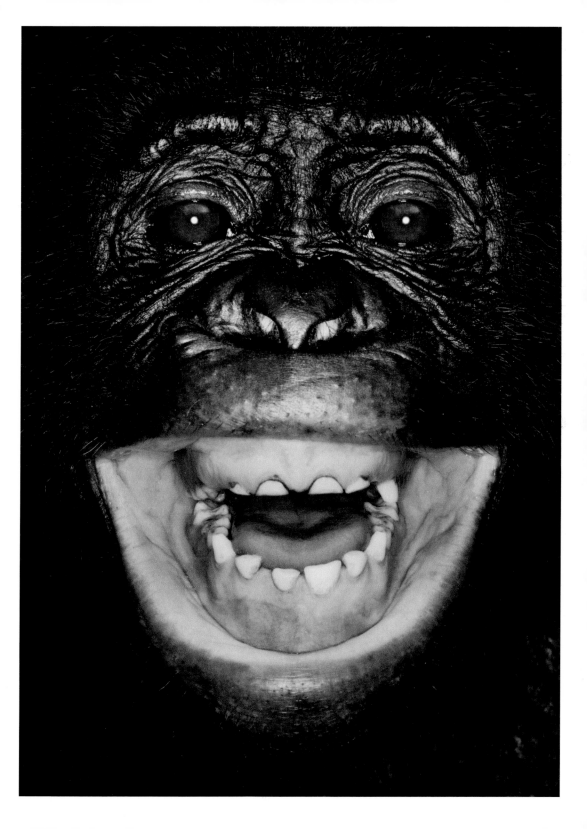

Chim, 5 years, *Pan troglodytes*, female, born Cameroon.

Talian, 3 years, *Pan troglodytes*, male, born Republic of Congo.

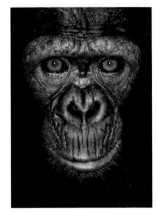

Tam Tam, 4 years, *Pan troglodytes*, female, born Cameroon.

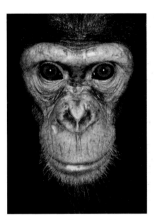

Wazak, 4 years, *Pan troglodytes*, female, born Cameroon.

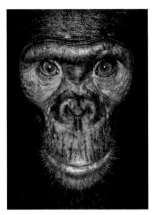

O'Minou, 4 years, *Pan troglodytes*, female, born Republic of Congo.

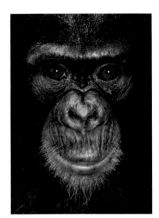

Achille, 2 years, *Pan troglodytes*, male, born Cameroon.

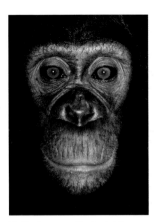

Fani'tuek, 3 years, *Pan troglodytes*, female, born Republic of Congo.

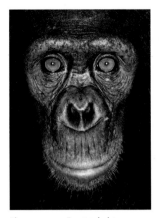

Liana, 5 years, *Pan troglodytes*, female, born Cameroon.

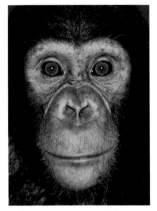

Jackson, 2 years, *Pan troglodytes*, male, born Cameroon.

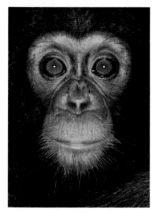

Arron, 11 months, *Pan troglodytes*, male, born Cameroon.

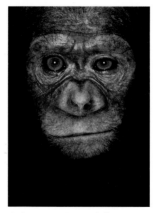

Katie, 2 years, *Pan troglodytes*, female, born Cameroon.

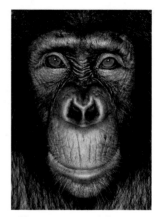

Talila, 5 years, *Pan troglodytes*, female, born Cameroon.

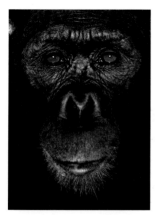

Rambo, 6 years, *Pan troglodytes*, male, born Cameroon.

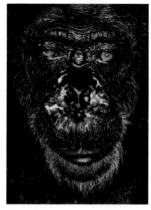

Gregoire, 60 years, *Pan troglodytes*, male, born Republic of Congo.

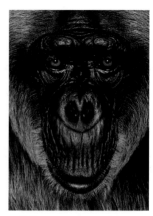

La Vieille, 29 years, *Pan troglodytes*, female, born Republic of Congo.

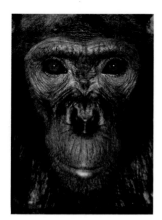

Wendy, 7 years, *Pan troglodytes*, female, born Cameroon.

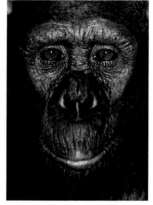

Koffi, 5 years, *Pan troglodytes*, male, born Cameroon.

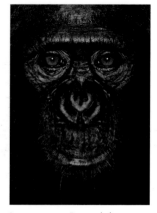

James, 5 years, *Pan troglodytes*, male, born Cameroon.

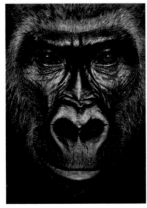

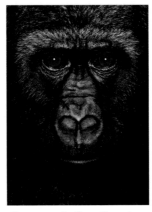

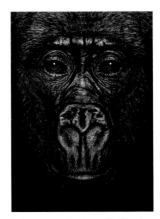

Pumbu, 8 years, *Gorilla gorilla*, female, born Republic of Congo.

Kibu, 3 years, *Gorilla gorilla*, male, born Cameroon.

Lulu, 4 years, *Gorilla gorilla*, female, born Republic of Congo.

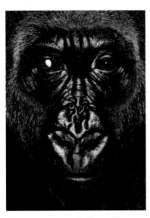

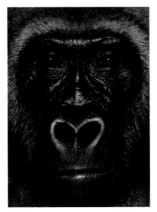

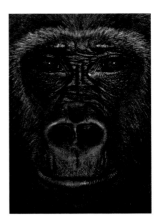

Nyango, 11 years, *Gorilla gorilla*, female, born Nigeria.

Koto, 8 years, *Gorilla gorilla*, female, born Republic of Congo.

Djeke, 9 years, *Gorilla gorilla*, male, born Republic of Congo.

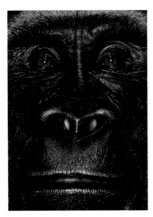

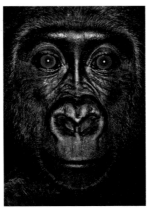

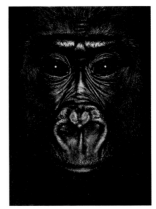

Kola, 14 years, *Gorilla gorilla*, male, born Republic of Congo.

Likendze, 4 years, *Gorilla gorilla*, female, born Republic of Congo.

Matoko, 4 years, *Gorilla gorilla*, female, born Republic of Congo.

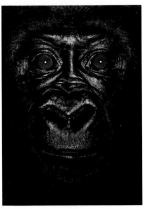

Helene, 4 years, *Gorilla gorilla,* female, born Republic of Congo.

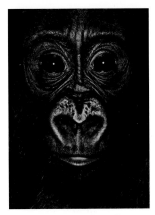

Nkan, 6 months, *Gorilla gorilla,* male, born Cameroon.

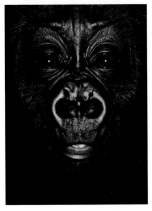

Shanga, 2 years, *Gorilla gorilla,* female, born Germany.

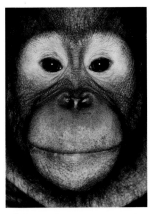

Joji, 6 years, *Pongo pygmaeus,* male, born Indonesia.

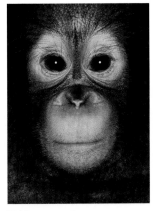

Haidar, 2 years, *Pongo pygmaeus,* male, born Indonesia.

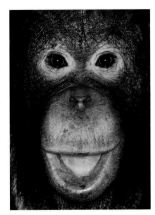

Kudel, 10 years, *Pongo pygmaeus,* male, born Indonesia.

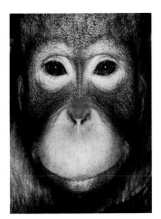

Ya-uuk, 7 years, *Pongo pygmaeus,* male, born Indonesia.

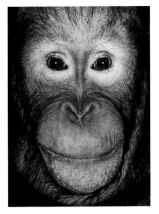

Simon, 8 years, *Pongo pygmaeus,* male, born Indonesia.

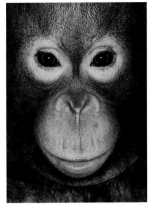

Inge, 5 years, *Pongo pygmaeus,* female, born Indonesia.

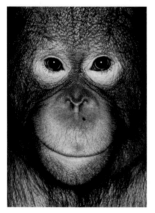

Zidane, 7 years, *Pongo pygmaeus*, male, born Indonesia.

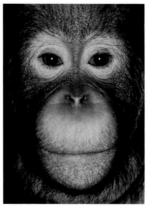

Bonny, 5 years, *Pongo pygmaeus*, male, born Indonesia.

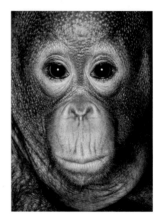

Jovan, 3 years, *Pongo pygmaeus*, male, born Indonesia.

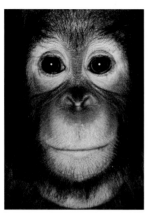

Ciu, 3 years, *Pongo pygmaeus*, male, born Indonesia.

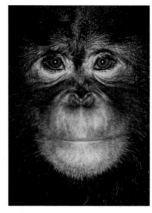

Millie, 3 years, *Pongo pygmaeus*, female, born USA.

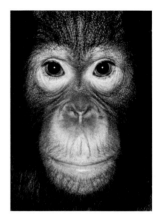

Rio, 6 years, *Pongo pygmaeus*, male, born Indonesia.

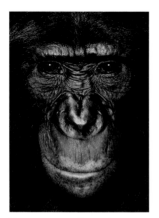

Tatango, 11 years, *Pan paniscus*, female, born DR Congo.

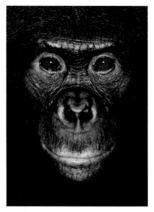

Noiki, 5 years, *Pan paniscus*, female, born DR Congo.

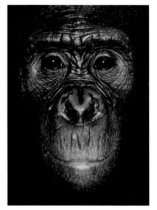

Inogo, 7 years, *Pan paniscus*, male, born DR Congo.

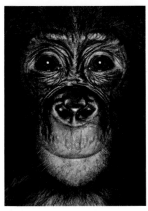

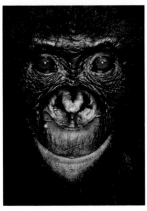

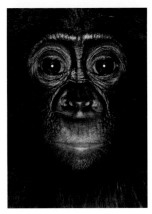

Likasi, 4 years, *Pan paniscus*, female, born DR Congo.

Lisala, 3 years, *Pan paniscus*, female, born DR Congo.

Fizi, 2 years, *Pan paniscus*, male, born DR Congo.

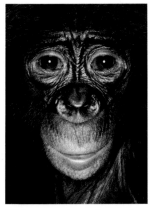

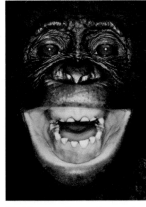

Dilolo, 2 years, *Pan paniscus*, male, born DR Congo.

Kitwiti, 5 years, *Pan paniscus*, male, born DR Congo.

Species types

Bonobo *Pan paniscus*
Chimpanzee *Pan troglodytes*
Gorilla *Gorilla gorilla*
Orangutan *Pongo pygmaeus*

Biographies

Achille, p21
2 years, *Pan troglodytes*, male, born
Cameroon.
Parents killed for bushmeat trade. Left by
expatriate family who had kept her as pet
in Bankim. In very bad condition on
arrival. Bad health continued with
suspected meningitis.
Photographed at Cameroon Wildlife Aid
Fund, Mvog Betsi Zoo, December 2001.

Arron, p29
11 months, *Pan troglodytes*, male, born
Cameroon.
Parents killed for bushmeat trade.
Confiscated by Ministry of Environment
and Forestry while being held by hunters.
Initially transferred to Sanaga Yong
Sanctuary.
Photographed at Cameroon Wildlife Aid
Fund, Bastos, December 2001.

Bonny, p85
5 years, *Pongo pygmaeus*, male, born
Indonesia.
Mother killed so he could be taken for live
animal trade. Brought to zoo sanctuary by
owner afraid of arrest by police.
Transferred to larger reservation. Soon to
be released into the wild.
Photographed at Ragunan Zoo,
Indonesia, August 2002.

Chim, p11
5 years, *Pan troglodytes*, female, born
Cameroon.
Parents killed for bushmeat trade. Left at
sanctuary by Cameroonian environmental
journalist who had kept her like a child,
dressed her, bathed her, etc. Bad mouth
injury, riddled with worms. Had been
made to dance in order to receive food.
Still dances when not fed on demand.
Photographed at Cameroon Wildlife Aid
Fund, Mvog Betsi Zoo, December 2001.

Ciu, p89
3 years, *Pongo pygmaeus*, male, born
Indonesia.
Mother killed so he could be taken for live
animal trade. Found by priest alone on
small road outside forest. Lived with
priest's family at Sangatta, East
Kalimantan. Very small. Loves to eat.
Favourite among keepers at Wanariset.
One of laziest orangutans in group. Rarely
climbs high; likes climbing low then
diving to ground or on to technicians.
Bites anyone who disturbs his two
surrogate mothers Sion and Ipeh.
Photographed at Wanariset Orangutan
Reintroduction Project, Indonesia, August
2002.

Dilolo, p107
2 years, *Pan paniscus*, male, born DR
Congo.
Parents killed for bushmeat trade.
Brought to sanctuary offered for sale by
local taxi driver. Sanctuary founder
refused, to discourage hunters. Later
siezed from taxi driver by Ministry of
Environment. Health very bad, totally
bald.
Photographed at Les Amis des Bonobos
du Congo, DR Congo, May 2003.

Djeke, p57
9 years, *Gorilla gorilla*, male, born
Republic of Congo.
Parents killed for bushmeat trade.
Confiscated from poacher attempting sale
to expatriates in Brazzaville. Part of middle
finger missing. Now dominant male of a
group of nine reintroduced gorillas.
Photographed at the Lesio-Louna
Reserve, Republic of Congo, May 2003.

Fani'tuek, p23
3 years, *Pan troglodytes*, female, born
Republic of Congo.
Parents killed for bushmeat trade.
Brought to sanctuary by Ministry of
Waters and Forests with Mamanhi and
one other chimpanzee, after time at
Brazzaville Zoo. Name means 'Where are
we?' in Villi.
Photographed at JGI Tchimpounga
Sanctuary, Republic of Congo, May 2003.

Fizi, p105
2 years, *Pan paniscus*, female, born DR
Congo.
Parents killed for bushmeat trade. Kept by
Kinshasa Zoo when very young, in empty
concrete shed. Observed there in great
distress by Congolese volunteer. Eventually
moved by Les Amis des Bonobos du
Congo to sanctuary.
Photographed at Les Amis des Bonobos
du Congo, DR Congo, May 2003.

Gregoire, p37
60 years, *Pan troglodytes*, male, born
Republic of Congo.
Parents killed for bushmeat trade.
Discovered by Jane Goodall in Brazzaville
Zoo in 1991. Severely malnourished and
almost hairless. Jane Goodall Institute
employed keeper to look after him and
encouraged expatriates to provide food.
Moved to Pointe Noire shortly
afterwards. Believed to be the oldest
chimpanzee in the world.
Photographed at JGI Tchimpounga
Sanctuary, Republic of Congo, May 2003.

Haidar, p73
2 years, *Pongo pygmaeus*, male, born
Indonesia.
Mother killed so he could be taken for
live animal trade. Kept as pet with rich
family in Semarang, central Java. Given
up once family finally persuaded of
illegality and risks to health. Weak on
arrival and very spoilt, eating only certain
kinds of fruit, only in small amounts.
Now much better, much stronger. Likes
all fruit, likes climbing trees in forest.
Has good self-confidence.
Photographed at Wanariset Orangutan
Reintroduction Project, Indonesia, August
2002.

Helene, p65
4 years, *Gorilla gorilla*, female, born
Republic of Congo.
Parents killed for bushmeat trade.
Bought as a pet by an Italian, reared as a
human baby. Eventually surrendered to
Projet Protection des Gorilles. Has
difficulty relating to other gorillas. In
youngest group of gorillas not yet
reintroduced.
Photographed at Projet Protection des
Gorilles, Republic of Congo, May 2003.

Inge, p81
5 years, *Pongo pygmaeus*, female, born
Indonesia.
Mother killed so Inge could be taken for
live animal trade. Bought from a hunter
for 30.000 rupiah (US$4). Remained
with owner for 3 years. Fed daily only a
little milk, 6 pieces of banana, rice and
instant noodles. Confiscated by
Wanariset team and East Kalimantan
KSDA. Very weak on arrival. Oldest
member of baby group by far. Did not like
to play with other orangutans, preferred
to sit alone in playground. Extra attention
from keepers required. Took several
months to adapt.
Photographed at Wanariset Orangutan
Reintroduction Project, Indonesia, August
2002.

Inogo, p99
7 years, *Pan paniscus*, male, born DR Congo.
Parents killed for bushmeat trade. Brought by vendor to animal merchants in Kinshasa. Seized by Ministry of Environment officer.
Photographed at Les Amis des Bonobos du Congo, DR Congo, May 2003.

Jackson, p27
2 years, *Pan troglodytes*, male, born Cameroon.
Parents killed for bushmeat trade. No information available from sanctuary.
Photographed at Limbe Wildlife Center, Cameroon, December 2001.

James, p45
5 years, *Pan troglodytes*, male, born Cameroon.
Parents killed for bushmeat trade. Confiscated from hunters in eastern province by Ministry of Environment and Forestry.
Photographed at Cameroon Wildlife Aid Fund, Mvog Betsi Zoo, December 2001.

Joji, p71
6 years, *Pongo pygmaeus*, male, born Indonesia.
Mother killed so he could be taken for live animal trade. Smuggled to Japan through Ngurai Rai Airport, Bali. Confiscated from Japanese pet shop. Died in June 2003, from diarrhoea.
Photographed at Wanariset Orangutan Reintroduction Project, Indonesia, August 2002.

Jovan, p87
3 years, *Pongo pygmaeus*, male, born Indonesia.
Mother killed so he could be taken for live animal trade. About to be smuggled out of Tanjung Priok port, Jakarta, when confiscated by forest rangers. Quiet. Sometimes plays with other orangutans, sometimes prefers to play alone. Good climber, very self-confident in forest, likes to climb high. Occasionally looks to keeper for comfort and courage. Does not like to sleep alone.
Photographed at Wanariset Orangutan Reintroduction Project, Indonesia, August 2002.

Katie, p31
2 years, *Pan troglodytes*, female, born Cameroon.
Parents killed for bushmeat trade. Confiscated by gamekeeper from hunter who had kept her in small box in hut in village of Akom. Suffers from a mental disorder.
Photographed at Cameroon Wildlife Aid Fund, Mefou National Park, December 2001.

Kibu, p49
3 years, *Gorilla gorilla*, male, born Cameroon.
Parents killed for bushmeat trade. Rescued by television crew from logging concession hunters in eastern Cameroon. 2-3 weeks old on arrival. Several shot-gun pellets in arm. Not expected to survive but put under intensive care. Suffers from a mental disorder.
Photographed at Cameroon Wildlife Aid Fund, Mefou National Park, December 2001.

Kitwiti, p109
4 years, *Pan paniscus*, male, born DR Congo.
Parents killed for bushmeat trade. Given by vendor from Oshné to cousin at Ministry of Agriculture. Brought to sanctuary. Had been mutilated: some teeth torn out and fingers missing. Rather simple but quickly gained confidence with surrogate mother. Walks around centre and welcomes visitors. Nicknamed sanctuary ambassador.
Photographed at Les Amis des Bonobos du Congo, DR Congo, May 2003.

Koffi, p43
5 years, *Pan troglodytes*, male, born Cameroon.
Parents killed for bushmeat trade. Kept by Cameroonian family in Yaounde who tried to sell him when he became too big and boisterous. Confiscated by Ministry of Environment and Forestry.
Photographed at Cameroon Wildlife Aid Fund, Mvog Betsi Zoo, December 2001.

Kola, p59
14 years, *Gorilla gorilla*, male, born Republic of Congo.
Parents killed for bushmeat trade. Confiscated by environment agents in Pointe Noire, aged about one year. Poor condition, dehydrated, malnourished, with rope burns on hips, a broken toe, stressed. Reintroduced in Lesio-Louna Reserve in 1997 but moved to enclosure after repeated forays outside reserve.
Photographed at Projet Protection des Gorilles, Republic of Congo, May 2003.

Koto, p55
8 years, *Gorilla gorilla*, female, born Republic of Congo.
Parents killed for bushmeat trade. Sold to vendor by hunter on Nzambi. Confiscated after 2 months and delivered to Brazzaville orphanage by plane. Rather depressed, dehydrated, yaws around nose, mouth and ears. Recovered health with help of surrogate mother. Reintroduced into Djeke's group. Now dominant female.
Photographed at the Lesio-Louna Reserve, Republic of Congo, May 2003.

Kudel, p75
10 years, *Pongo pygmaeus*, male, born Indonesia.
One of largest and most adventurous apes in the sanctuary. Likes to play practical jokes on fellow apes and handlers, knocking them over and being the centre of attention. Likes to show off, climbing trees and being served first at mealtimes. Named by a German woman, 'kuddel' being North German dialect for 'cuddly, friendly animal'.
Photographed at Ragunan Zoo, Indonesia, August 2002.

La Vieille, p39
29 years, *Pan troglodytes*, female, born Republic of Congo.
Parents killed for bushmeat trade. Rescued by Jane Goodall Institute in Pointe Noire. Had never experienced anything except rusty cage. Moved to Tchimpounga with Gregoire. Only dared step out of sleeping enclosure after 6 years.
Photographed at JGI Tchimpounga Sanctuary, Republic of Congo, May 2003.

Liana, p25
5 years, *Pan troglodytes*, female, born Cameroon.
Parents killed for bushmeat trade. Kept in little box and aggressively beaten. Confiscated by Ministry of Environment and Forestry in Yaounde. The box was her world on arrival at CWAF and she would attack anybody who tried to take her out. Finally coaxed out after 4 days. About 18 months old. Health very poor. Hair receding.
Photographed at Cameroon Wildlife Aid Fund, Mefou National Park, December 2001.

Likasi, p101
4 years, *Pan paniscus*, female, born DR
Congo.
Parents killed for bushmeat trade. Offered
for sale by Brazzaville Zoo who contacted
local Ministry. Confiscated by Projet
Protection Gorilles. First of six apes to be
seized in North Congo.
Photographed at Les Amis des Bonobos
du Congo, DR Congo, May 2003.

Likendze, p61
4 years, *Gorilla gorilla*, female, born
Republic of Congo.
Parents killed for bushmeat trade. Was
being sold as a pet with Matoko. Rescued,
with hunters caught in Ministry of
Environment trap. In the youngest group
of gorillas, not yet reintroduced.
Photographed at Projet Protection des
Gorilles, Republic of Congo, May 2003.

Lisala, p103
3 years, *Pan paniscus*, female, born DR
Congo.
Parents killed for bushmeat trade. Offered
for sale by Brazzaville Zoo who contacted
local Ministry. Confiscated by Projet
Protection Gorilles. Among first six apes
to be seized in North Congo.
Photographed at Les Amis des Bonobos
du Congo, DR Congo, May 2003.

Lulu, p51
4 years, *Gorilla gorilla*, female, born
Republic of Congo.
Parents killed for bushmeat trade. Found
by Government environment agents in
poacher's hut in isolated northern village,
sitting next to her mother's decaying
head. Very dehydrated on arrival, with
sunken eyes and loose skin. Very alert,
drank c 60 ml plain water, ate half a
banana, white spots noticed on lips. Very
restless during the night, crying and
hooting. Recovered health with help of
surrogate mother at Projet Protection des
Gorilles. Reintroduced into Djeke's
group.
Photographed at the Lesio-Louna
Reserve, Republic of Congo, May 2003.

Matoko, p63
4 years, *Gorilla gorilla*, female, born
Republic of Congo.
Parents killed for bushmeat trade. Was
being sold as a pet with Likendze.
Rescued, with hunters caught in Ministry
of Environment trap. In the youngest
group of gorillas, not yet reintroduced.
Photographed at Projet Protection des
Gorilles, Republic of Congo, May 2003.

Millie, p91
3 years, *Pongo pygmaeus*, female, born
USA.
Rejected by mother. Diagnosed with
cerebral palsy, the only orangutan known
to survive with the disease. Needs
constant care.
Photographed at Parrot Island Jungle,
Florida, USA, September 2004.

Nkan, p67
6 months, *Gorilla gorilla*, male, born
Cameroon.
Parents killed for bushmeat trade.
Confiscated by Karl Amaan from a woman
travelling to Yaounde to offer him for sale,
aged 2 weeks. Passed to CWAF.
Photographed at Cameroon Wildlife Aid
Fund, Bastos, December 2001.

Noiki, p97
5 years, *Pan paniscus*, female, born DR
Congo.
Parents killed for bushmeat trade.
Abandoned near-dead by soldiers fighting
war in Nioki. Found by traveller and
brought to sanctuary. Given mouth-to-
mouth resuscitation, water, spaghetti.
Photographed at Les Amis des Bonobos
du Congo, DR Congo, May 2003.

Nyango, p53
11 years, *Gorilla gorilla*, female, born
Nigeria.
Parents killed for bushmeat trade. Sold
as pet to missionary before rescue by
Limbe Wildlife Center. Thought to be a
rare 'cross river gorilla'.
Photographed at Limbe Wildlife Center,
Cameroon, December 2001.

O'Minou, p19
4 years, *Pan troglodytes*, female, born
Republic of Congo.
Parents killed for bushmeat trade.
Brought to the sanctuary by Ministry of
Waters and Forests after a period at
Brazzaville Zoo. Name means 'There is
nobody but me' in Villi. Slight squint and
scant fur.
Photographed at JGI Tchimpounga
Sanctuary, Republic of Congo, May 2003.

Pumbu, p47
8 years, *Gorilla gorilla*, female, born
Republic of Congo.
Parents killed for bushmeat trade.
Confiscated from vendor in Pointe
Noire. Aged about 9 months on arrival.
Scar above right eye, two healed cuts on
left hand, very thin, coughing a lot,
obviously scared. Drank one bowl milk,
one bowl of water, ate one banana. Slept
well during night, a lot of scratching,
possible mites problem. Recovered
health with help of surrogate mother at
Projet Protection des Gorilles.
Reintroduced into Djeke's group.
Photographed at the Lesio-Louna
Reserve, Republic of Congo, May 2003.

Rambo, p35
6 years, *Pan troglodytes*, male, born
Cameroon.
Parents killed for bushmeat trade.
Confiscated by the Ministry of
Environment and Forestry from a woman
who kept him like a human child,
wearing clothes, brushing teeth, etc. 4
years old on arrival. Quickly became
dominant male of group.
Photographed at Cameroon Wildlife Aid
Fund, Mefou National Park, December
2001.

Rio, p93
6 years, *Pongo pygmaeus*, male, born
Indonesia.
Mother killed so he could be taken for
live animal trade. Lived for some time
with owner, who became afraid once Rio
grew too large and strong. Extremely
stressed on arrival. Recently released
into the wild.
Photographed at Ragunan Zoo,
Indonesia, August 2002.

Shanga, p69
2 years, *Gorilla gorilla*, female, born
Germany.
Had to be taken from mother because
she had no milk. Now cared for by
surrogate human mother before return
to zoo's group.
Photographed at Berlin Zoo, Germany,
May 2001.

Simon, p79
8 years, *Pongo pygmaeus*, male, born Indonesia.
Mother killed so he could be taken for live animal trade. Treated as a human child by previous owner. Brought to the sanctuary when too big and strong. Health on arrival decent, but quite anxious. Bald spots where hair torn out through stress. Health now very good. Excellent, calm character.
Photographed at Ragunan Zoo, Indonesia, August 2002.

Talian, p13
3 years, *Pan troglodytes*, male, born Republic of Congo.
Parents killed for bushmeat trade. Brought to sanctuary by Ministry of Waters and Forests after time at Brazzaville Zoo. Name means 'Hope' in Villi. No special characteristics and nothing known prior to rescue.
Photographed at JGI Tchimpounga Sanctuary, Republic of Congo, May 2003.

Talila, p33
5 years, *Pan troglodytes*, female, born Cameroon.
Parents killed for bushmeat trade. Confiscated by Ministry of Environment and Forestry, circumstances unknown.
Photographed at Cameroon Wildlife Aid Fund, Mvog Betsi Zoo, December 2001.

Tam Tam, p15
4 years, *Pan troglodytes*, female, born Cameroon.
Parents killed for bushmeat trade. Confiscated by Ministry of Environment and Forestry in eastern province of Cameroon. Piece missing from outer ear. Facially very expressive.
Photographed at Cameroon Wildlife Aid Fund, Mvog Betsi Zoo, December 2001.

Tatango, p95
11 years, *Pan paniscus*, female, born DR Congo.
Parents killed for bushmeat trade. Seized at valuables market in eastern Kinshasa.
Photographed at Les Amis des Bonobos du Congo, DR Congo, May 2003.

Wazak, p17
4 years, *Pan troglodytes*, female, born Cameroon.
Parents killed for bushmeat trade. Confiscated by CWAF driver after sighting in Yaounde market. Name Wazak is a combination of Wa (local dialect word for chimp) and driver's name Zac. Very facially expressive.
Photographed at Cameroon Wildlife Aid Fund, Mvog Betsi Zoo, December 2001.

Wendy, p41
7 years, *Pan troglodytes*, female, born Cameroon.
Parents killed for bushmeat trade. Given to sanctuary by Chinese family who had held her for six years. Often walked upright, very gentle. On arrival at CWAF spent 2 weeks in a cage at the side of enclosure, to get to know other chimpanzees. When entered group, all chimpanzees liked her, no fighting.
Photographed at Cameroon Wildlife Aid Fund, Mefou National Park, December 2001.

Ya-uuk, p77
7 years, *Pongo pygmaeus*, male, born Indonesia.
Mother killed so he could be taken for live animal trade. Brought to Jakarta Zoo by owner. About 3 years old on arrival, in decent health. Has sucked his thumb ever since, although now fully grown. Best friend is Villo, an orangutan who as a baby lost his nose when his mother shot by poachers and fell on top of him.
Photographed at Ragunan Zoo, Indonesia, August 2002.

Zidane, p83
7 years, *Pongo pygmaeus*, male, born Indonesia.
Mother killed so he could be taken for live animal trade. Confiscated from smugglers. On arrival at zoo sanctuary, poorly hydrated and afraid of everyone. Needed special care and great patience, but was accepted without difficulty into resident group of apes. Still rather shy but health excellent. Soon to be transferred to larger sanctuary.
Photographed at Ragunan Zoo, Indonesia, August 2002.

Sanctuaries

JGI's Tchimpounga Sanctuary
PointeNoire, Republic of Congo
www.janegoodall.org

Cameroon Wildlife Aid Fund (CWAF)
Yaounde, Cameroon
www.cwaf.org

Limbe Wildlife Center
Limbe, Cameroon
www.limbewildlife.org

Project Protection des Gorilles (PPG)
Brazzaville, Republic of Congo
www.howletts.net

Les Amis des Bonobos du Congo
Kinshasa, Democratic Republic of Congo
bonoboducongo.free.fr

Ragunan Zoo
Jakarta, Indonesia

Wanariset Orangutan Reintroduction Project
Balikpapan, East Kalimantan, Indonesia
www.savetheorangutan.info

Thank you

Claudine André, Freya Averley, Helen Averley, Joanna Averley, Brian Carroll, Christelle Chamberlan, Laura Balich, Samantha Bartoletti, Grégoire Basdevant, Zac Beattie, Michela Beccacece, Stefano Beggiato, Luciano Benetton, Jean Marie Benishay, Joel Berg, Bob Bloomfield, Chris Boot, Katie Boot, Susan Bright, Adam Broomberg, Peter & Elisabeth Bostock, Carlo & Maria Callegari, Tomaso Cavana, Bruno Ceschel, Oliver Chanarin, Isabel Codani, Brice Compagnon, Amos Courage, Graziella Cotman, Sally Coxe, Doug Cress, Victor De la Torre Sans, Jane T. Dewar, Jared Diamond, Daymo Duncan, Valerio Fanfoni, Amy Flanagan, Bill Field, Anna & Dave Frampton, Jane Goodall, Rachel Hogan, Charlotte Hosten, Leo Hulsker, Linda Jacobs, Francesca Jaimes, Parag Kapashi, Tony King, Klika, Herner Kloes, Alfred Kombele, Paolo Landi, Andrea Lecardi, Mary Lewis, Jeane Mandala, Chunko McGlade, Chris Michel, Simon & Jane Mollison, Carlos & Jules, Pablo, Ernesto & Soraya Mustienes, Barbara Ossenkop, Martin Parr, Laura Pollini, Elisabetta Prando, Patti Regan, Renzo di Renzo, Saira Robertson, Sue Savage Rumbaugh, Ottorino Savio, Mimmo Samele, Bree Seeley, Catalina Sierra Thomas, Sarah Sharples, Smith, Willie Smitts, Cristiano Spiller, Paul Stuart, Lloyd Thomas, Oliviero Toscani, Robert Vattilana, Ulrike Von Mengden, Barbara Walsh, Tyler Whisnand, Tony Wright, Bona Zanazzo

James Mollison, *Venice, May 2004*

James & Other Apes
by James Mollison

First published 2004
This edition published 2005
by Chris Boot

Chris Boot Ltd.
79 Arbuthnot Road
London SE14 5NP
Tel. +44 20 7639 2908
www.chrisboot.com

© Chris Boot Ltd.
Photographs © James Mollison
Introduction text © Jane Goodall

Design by Marco Callegari
Lithography by ABC, Milan

Distribution (except North America) by
Thames & Hudson Ltd.
181A High Holborn
London WC1V 7QX

A CIP catalogue record for this book is
available from the British Library

ISBN 0-9546894-3-7

Printed by EBS, Italy